Contents

Inclusive Accessible Design

by Adrian Cave

Series Editors: Sarah Lupton and Manos Stellakis

RIBA ⅲ Publishing

© Adrian Cave, 2007
Published by RIBA Publishing, 15 Bonhill Street, London EC2P 2EA

ISBN-13 978 1 85946 250 8

Stock Code 61455

British Library Cataloguing in Publications Data
A catalogue record for this book is available from the British Library.

Publisher: Steven Cross
Commissioning Editor: Matthew Thompson
Project Editor: Kelly Hallett
Designed by Philip Handley
Typeset by Academic + Technical, Bristol
Printed and bound by MPG, Cornwall

RIBA Publishing is part of RIBA Enterprises Ltd. www.ribaenterprises.com
Cover photograph: © Santokh Kochar/Getty Images

Legislation Maze series

This guide comprises short, easy-to-use, topic-based guides to legislation for construction professionals (architects, engineers, surveyors, facilities managers, contractors) and students in construction related fields. The series focuses on aspects of design and job management that are controlled by several statutory instruments and related codes and approved documents, and where, in practice, assimilating these can be difficult and time-consuming.

The series provides "maps" to guide readers round the various relevant publications, with explanatory discussion as to their significance and relevance. It indicates which documents (and sections of documents) should be consulted in any given design context (for example, relating to building type, use, location, etc), and which are particularly relevant at each RIBA work stage. It also covers commonly occurring problems and gives lists of "watch points" relating to the topic. As the primary purpose is to "point people in the right direction", the series contains only limited discussion of the technical content of the legislation, but refers the reader to other technical texts for detailed commentary.

The series provides a quick reference point for use during a working project, set out on a work stage basis. It provides practical, management-based guides, pointing out the operational implications of the legislation (for example, when other consultants may need to be brought in), cross-linking the subject to different pieces of legislation and assessing the combined effect on aspects of design and job management. It expands on issues pinpointed in the *Architect's Job Book* and provides a bridge between these and existing technical publications.

Inclusive design, like the other topics in the series, is something to be considered at all RIBA Work Stages, and to fully understand all the issues the designer will need to consult a wide range of complex legislation and guidance. Particularly important is, of course, the Disability Discrimination Act 1995, Part 3 of which has been fully in force since October 2004. This guide presents a detailed map of the provisions of the DDA, together with the Disability Rights Commission Code of Practice "Rights of Access" (published 2002), Approved Document B (effective from April 2007) and numerous other Codes, Standards and design guides.

Sarah Lupton and Manos Stellakis
(Series editors)

1. Introduction

How to use this book

This publication is intended to enable designers to take a creative approach in responding to the requirements of the Disability Discrimination Act 1995, Part M of the Building Regulations and the provisions of Approved Document Part M. To do this, it is necessary to understand the reasons behind the guidance published in documents such as BS 8300 and in the sections on design considerations in Approved Document Part M, which states that "Approved Documents are intended to provide guidance for some of the more common building situations. However, there may well be alternative ways of achieving compliance with the requirements. Thus there is no obligation to adopt any particular solution contained in an Approved Document if you prefer to meet the relevant requirements in some other way."

1. To start

To identify the access issues on which information or guidance is required, use one of the following charts:

1. Finding a way through the legal maze – buildings other than dwellings
2. Finding a way through the legal maze – dwellings

Use the references in the chart to find either a summary of the information or guidance in this book or, for more detailed information, refer to the original documents.

2. RIBA work stage sequence

This book is arranged according to the RIBA Plan of Work, so that the sources of information required to make decisions about access and inclusive design can be identified at each stage of the work. For example:

Stage AB	Appraisal and design brief	Part 2, Legislative framework Part 3, Inclusive policies
C	Concept	Part 4, BS 8300
DE	Design development and technical design	Part 5, Approved Document M, Lifetime Homes
FGHJK	Production information, tender documentation and action, mobilisation and construction to practical completion	Part 5, Approved Document M, Lifetime Homes Part 6, Approved Document M details
L	Post practical completion	Part 7, Management, adjustment and auxiliary aids for individuals

3. BS 8300 and Approved Document M comparisons

The relationship between these two key documents is shown by cross-references, so as to enable the provisions in Approved Document Part M (ADM) to be compared with the research and guidance in the British Standard.

4. Guidelines to good practice for the public realm

Although not subject to Approved Document M, it is often considered reasonable to adopt the guidelines in BS 8300 and the ADM when designing public circulation routes, vehicular circulation and parking, open space and recreational facilities. Other relevant publications, also cross-referenced to ADM, are "Inclusive Mobility" (Department of Transport, 2002) and "Planning and Access for Disabled People: A Good Practice Guide" (ODPM, 2003).

5. Guidelines to good practice for buildings

A wide range of publications are referred to and cross-referenced to the relevant provisions of ADM, enabling varied examples of suggested good practice to be compared and evaluated.

6. Access Statements

At the stages of both town planning applications and Building Regulations submissions, Access Statements should be able to explain the reasons for the planning and design decisions about access and inclusive design. Examples of the typical headings and format are provided for town planning (Part 4) and Building Regulations (Part 9).

Chart 1
Finding a way through the legal maze – buildings other than dwellings

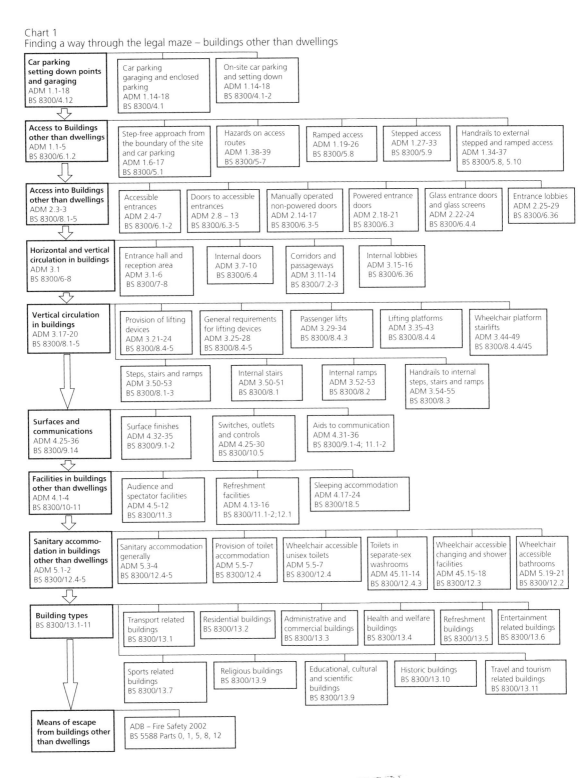

Car parking setting down points and garaging
ADM 1.1-18
BS 8300/4.12

Car parking garaging and enclosed parking
ADM 1.14-18
BS 8300/4.1

On-site car parking and setting down
ADM 1.14-18
BS 8300/4.1-2

Access to Buildings other than dwellings
ADM 1.1-5
BS 8300/6.1.2

Step-free approach from the boundary of the site and car parking
ADM 1.6-17
BS 8300/5.1

Hazards on access routes
ADM 1.38-39
BS 8300/5-7

Ramped access
ADM 1.19-26
BS 8300/5.8

Stepped access
ADM 1.27-33
BS 8300/5.9

Handrails to external stepped and ramped access
ADM 1.34-37
BS 8300/5.8, 5.10

Access into Buildings other than dwellings
ADM 2.3-3
BS 8300/8.1-5

Accessible entrances
ADM 2.4-7
BS 8300/6.1-2

Doors to accessible entrances
ADM 2.8 – 13
BS 8300/6.3-5

Manually operated non-powered doors
ADM 2.14-17
BS 8300/6.3-5

Powered entrance doors
ADM 2.18-21
BS 8300/6.3

Glass entrance doors and glass screens
ADM 2.22-24
BS 8300/6.4.4

Entrance lobbies
ADM 2.25-29
BS 8300/6.36

Horizontal and vertical circulation in buildings
ADM 3.1
BS 8300/6-8

Entrance hall and reception area
ADM 3.1-6
BS 8300/7-8

Internal doors
ADM 3.7-10
BS 8300/6.4

Corridors and passageways
ADM 3.11-14
BS 8300/7.2-3

Internal lobbies
ADM 3.15-16
BS 8300/6.36

Vertical circulation in buildings
ADM 3.17-20
BS 8300/8.1-5

Provision of lifting devices
ADM 3.21-24
BS 8300/8.4-5

General requirements for lifting devices
ADM 3.25-28
BS 8300/8.4-5

Passenger lifts
ADM 3.29-34
BS 8300/8.4.3

Lifting platforms
ADM 3.35-43
BS 8300/8.4.4

Wheelchair platform stairlifts
ADM 3.44-49
BS 8300/8.4.4/45

Steps, stairs and ramps
ADM 3.50-53
BS 8300/8.1-3

Internal stairs
ADM 3.50-51
BS 8300/8.1

Internal ramps
ADM 3.52-53
BS 8300/8.2

Handrails to internal steps, stairs and ramps
ADM 3.54-55
BS 8300/8.3

Surfaces and communications
ADM 4.25-36
BS 8300/9.14

Surface finishes
ADM 4.32-35
BS 8300/9.1-2

Switches, outlets and controls
ADM 4.25-30
BS 8300/10.5

Aids to communication
ADM 4.31-36
BS 8300/9.1-4; 11.1-2

Facilities in buildings other than dwellings
ADM 4.1-4
BS 8300/10-11

Audience and spectator facilities
ADM 4.5-12
BS 8300/11.3

Refreshment facilities
ADM 4.13-16
BS 8300/11.1-2;12.1

Sleeping accommodation
ADM 4.17-24
BS 8300/18.5

Sanitary accommodation in buildings other than dwellings
ADM 5.1-2
BS 8300/12.4-5

Sanitary accommodation generally
ADM 5.3-4
BS 8300/12.4-5

Provision of toilet accommodation
ADM 5.5-7
BS 8300/12.4

Wheelchair accessible unisex toilets
ADM 5.5-7
BS 8300/12.4

Toilets in separate-sex washrooms
ADM 45.11-14
BS 8300/12.4.3

Wheelchair accessible changing and shower facilities
ADM 45.15-18
BS 8300/12.3

Wheelchair accessible bathrooms
ADM 5.19-21
BS 8300/12.2

Building types
BS 8300/13.1-11

Transport related buildings
BS 8300/13.1

Residential buildings
BS 8300/13.2

Administrative and commercial buildings
BS 8300/13.3

Health and welfare buildings
BS 8300/13.4

Refreshment buildings
BS 8300/13.5

Entertainment related buildings
BS 8300/13.6

Sports related buildings
BS 8300/13.7

Religious buildings
BS 8300/13.9

Educational, cultural and scientific buildings
BS 8300/13.9

Historic buildings
BS 8300/13.10

Travel and tourism related buildings
BS 8300/13.11

Means of escape from buildings other than dwellings

ADB – Fire Safety 2002
BS 5588 Parts 0, 1, 5, 8, 12

Chart 2
Finding a way through the legal maze – dwellings

| **Access to and into dwellings**
ADM 6.1-3
LTH 1-6 | Approach to the dwelling
ADNM 6.4-18
LTH 1, 2, 3 | Access into the dwelling
ADM 6.19-23
LTH 4, 6 |

| **Circulation within the entrance storey of the dwelling**
ADM 7.1
LTH 12 | Corridors, passageways and internal doors within the entrance storey
ADM 7.2-5 | Vertical circulation within the entrance storey
ADM 7.6-7 |

| **Accessible switches and socket outlets**
ADM 8.1-3
LTH 16 |

| **Passenger lifts and common stairs in blocks of flats**
ADM 9.1.4
LTH 5 | Common stairs
ADM 9.5
LTH 5a | Lifts
ADM 9.6-7
LTH 5b |

| **WC provision in the entrance storey of the dwelling**
ADM 10.1
LTH 7-11 and 13-1115 |

Lifetime Homes standards

1. Car parking
2. Distance from car park
3. Approach to dwelling
4. Entrance
5. Common stair/lift
6. Internal door widths etc
7. Wheelchair turning spaces
8. Living room at entrance level
9. Bedspace at entrance level
10. Accessible WC
11. Bathroom/WC walls to be reinforced
12. Provision for future lift
13. Provision for future hoist
14. Bathroom/WC spaces for wheelchair transfer
15. Windows
16. Switches, sockets, etc.

Wheelchair Housing design guide, 2006

1. Moving around outside
2. Using outdoor spaces
3. Approaching the home
4. Entrance door
5. Entering and leaving
6. Secondary door
7. Moving around inside
8. Moving between levels inside
9. Living spaces
10. Kitchen
11. Bathroom
12. Bedrooms
13. Bathroom
14. Windows
15. Controlling services

Means of escape from the dwelling
ADB Fire safety 2002
BS 5588 Parts 0, 1, 5, 8 and 12

4

2. Legal Framework

Medical and social models

The development of legislation about disabled people reflects changing attitudes to disability. Until the nineteenth century and, indeed, well into the twentieth century, disabled people were largely accommodated in institutions and the approach to dealing with disability was focussed on the nature of the disability and the medical symptoms. This approach has become known as the "medical model" and is no longer acceptable to the disabled community because it reinforces the misconceptions and stereotypes of disabled people as a group, such as "the disabled", "the blind", "the deaf" and worse still "the wheelchair bound". This term serves to illustrate the misleading consequences of medical labels because very few users of wheelchairs are "wheelchair bound" – most are able to stand or walk for a short time and the great majority seek as much independence as possible in their daily lives.

In order to be able to achieve independence and full participation in society, and to the extent that disability may or may not be seen as a "problem", most disabled people prefer to be considered as individuals rather than as members of a disabled group. In addition, most disabled people have developed skills that enable them to be largely independent, limited mainly by the problems of buildings and the physical environment. By this approach, the difficulties and limitations experienced by a disabled person in the social and physical environment are seen as the consequences of society's attitudes and decisions. This is the "social model".

Inclusive design

A pavement with a raised kerb is a serious obstacle for a wheelchair user yet a dropped kerb at junctions and corners is easy to provide and is advantageous to many more people than those who have a disability. Recognition of the many benefits to society as a whole of providing a social and physical environment which takes account of the needs of disabled people leads to the concept of inclusivity in many aspects of life. Current legislation and the Building Regulations are now focussed less on the needs of disabled people as such and more on "inclusive design" and "inclusive environments".

In the Disability Discrimination Act 1995, the definition of a person who is disabled is as follows: a person has a disability if he has a physical or mental impairment which has a substantial and long-term adverse effect on his ability to carry out normal day-to-day activities.

Concern for the needs of disabled people is reinforced by awareness of the implications of an aging population, with the prospect of many people becoming less mobile or experiencing sensory impairments during their later years. Aspirations towards enabling everyone to have access to buildings and to use their facilities have led, therefore, to the evolution of concepts for inclusive design.

The concept of inclusive design implies that it is more appropriate to design for the needs of people generally rather than for people with a specific disability. Increasing numbers of children's pushchairs and buggies, shopping trollies, luggage with wheels and people who have become less mobile with increasing age all indicate the benefit of inclusive design. This is quite apart from the needs of people who use wheelchairs or electric scooters. The problems faced by elderly people are particularly relevant because, unlike someone who has been disabled from childhood and who has a lifetime of developed skills to cope with the disability, elderly people become frail or begin to experience impairments of mobility, sight or other faculties at a time when it is difficult to acquire new skills. However, elderly people, just as disabled people, have a great desire for independence.

Chronology

In 1963, the seminal book *Designing for the Disabled* by Selwyn Goldsmith did much to raise awareness among architects about the nature of the difficulties experienced by disabled people in the built environment. Selwyn Goldsmith, an architect who was disabled by polio in his twenties, set out systematically the nature of the obstacles encountered by disabled people in moving around buildings and in using their facilities.

The Chronically Sick and Disabled Persons Act 1970 required that, in any building proposals, the means of access to and within the premises should "make provision, in so far as it is in the circumstances both practical and reasonable, for the needs of members of the public visiting the building or premises who are disabled."

The Building Regulations 1976 began to address for the first time the problems faced by disabled people, with the introduction of Part T, the forerunner of Part M. The Building Regulations of 1987 introduced Part M, "Access and facilities for disabled people", and Approved Document Part M provided guidance on how to meet these requirements. Approved Document Part M was revised and developed in 1992.

The turning point in legislation about disabled people came with the publication of the Disability Discrimination Act in 1995. This consists of a number of sections including:

Part 1: Definitions of disability
Part 2: Employment
Part 3: Provision of goods, facilities and services
Part 4: Education
Part 5: Transport (excluded from the requirements of Part 3)

Approved Document Part M was revised in 1999 and sought to ensure that disabled people were able to have "access to and use the facilities of a building."

The publication in 2001 of British Standard 8300 (BS 8300: 2001), "Design of buildings and their approaches to meet the needs of disabled people" set new and authoritative criteria for designing for disabled people based on extensive research and ergonomic studies. For the first time designers were able to refer to extensive and systematic guidance about how to design to meet the needs of disabled people. This British Standard is currently the main reference for standards of design for disabled people and, if challenged in a court of law, designers who have not followed the guidance of BS 8300 will have to be able to explain why they did not do so.

Approved Document Part M was revised again in 2004 to incorporate many of the recommendations of BS 8300. Significantly, Approved Document Part M 2004 (ADM 2004), now sought to ensure that "Reasonable provision shall be made for people to gain access to and use the building and its facilities". ADM 2004 requires that "People, regardless of disability, age or gender, should be able to: a) gain access to buildings and to gain access within buildings, use their facilities, both as visitors and as people who live or work in them; b) use sanitary conveniences in the principal storey of a new dwelling."

Note that instead of focussing on the needs of disabled people, ADM 2004 uses phrases such as requiring access for "people, including disabled people."

The Disability Discrimination Act 1995

The Disability Discrimination Act (DDA) makes it illegal to discriminate against a disabled person on the grounds of their disability in respect of employment and the provision of goods and services. The Act offers protection to those whose disabilities have a long-term adverse affect on their ability to carry out normal day-to-day activities. At a retail centre this would apply to all those people who enter the premises, whether as customers or as employees.

The Special Educational Needs and Disability Act 2001 (SENDA) established legal rights for disabled studets in pre- and post-16 education.

Under the terms of the DDA, and as summarised in the Code of Practice "Rights of Access" published by the Disability Rights Commission (DRC), "A person has a disability if he has a physical or mental impairment which has a substantial and long-term adverse effect on his ability to carry out normal day-to-day activities." The test of whether an impairment affects normal day-to-day activities is whether it affects one of the broad categories of capacity listed in the Act. These are:

- mobility
- manual dexterity
- physical co-ordination
- continence

- ability to lift, carry or otherwise move everyday objects
- speech, hearing or eyesight
- memory or ability to concentrate, learn or understand
- perception of the risk of physical danger.

The DDA has, since December 1996, made it unlawful for employers to discriminate on the grounds of a person's disability against current or potential employees and for service providers to refuse to serve, offer a lower standard of service on worse terms to, a disabled person for a reason relating to their disability. Further duties, affecting service providers, have been and will be introduced over time. For the purposes of the Act discrimination will have occurred when:

- for a reason that relates to a disabled person's disability the service provider or employer treats that disabled person less favourably than they would treat others to whom that reason does not or would not apply; and
- a service provider or employee fails to comply with a duty to make reasonable adjustment in relation to a disabled person as required by the DDA.

Whilst elements in respect of employment, such as the need to make reasonable adjustments and provide equipment, came into force in 1996, the remaining provisions in respect of goods and services are being phased in over a number of years. From October 1999 service providers have been required to make reasonable adjustment to practices, policies and procedures which would exclude disabled people, and to provide auxiliary aids and services to facilitate use of a service. From October 2004 should a permanent feature of a building make it unreasonable, steps should have been taken to remove, alter or avoid it if the service cannot be otherwise provided.

The risk to service providers under the DDA is that a successful action taken through the courts would entitle the complainant to seek compensation and might also result in a requirement to carry out costly adjustments to remove the barrier to accessing the service.

Because the DDA is not based on compliance but on "reasonable" provision in respect of the physical environment, the understanding of current good practice is subject to continuing development. An Access Statement is commonly used to explain and record the decisions taken for accessibility. Within this context, two of the main references used in the development of current good practice are: ADM 2004 and BS8300 (2001).

Access and emergency escape

The many implications of enabling disabled people to have improved access into buildings included the need to ensure that they would be able to escape safely

during a fire or other emergency. Previous escape arrangements had been based on the assumption that, in an emergency, people would be able to escape without assistance and, typically, by using fire escape stairs in protected compartments. This would clearly not be possible for wheelchair users and for many people who have impaired mobility.

One solution to this problem was to propose assisted evacuation with folding evacuation chairs which would be kept on the landings of the fire escape stairs but this raised almost as many problems as it solved. For example, evacuation chairs are not easy to use and, if a disabled person is very severely disabled or heavy, it is not easy to make the transfer into the evacuation chair and considerable strength and skill is required on the part of the assistant if the descent of the staircase is to be made safely. This contributed to the development of horizontal evacuation and safe refuges.

Approved Document B, 2006, (ADB) which became effective in April 2007, has three recommendations about the design considerations for disabled people that are particularly relevant.

First, on the subject of residential care homes, ADB states that "in care homes for the elderly it is reasonable to assume that at least a proportion of the residents will need some assistance to evacuate. As such these buildings should be designed for progressive horizontal evacuation (PHE)". The concept of PHE is described as requiring "those areas used for the care of residents to be subdivided into protected areas separated by compartment walls and compartment floors. This allows horizontal escape to be made by evacuating into adjoining protected areas. The objective is to provide a place of relative safety within a short distance, from which further evacuation can be made if necessary but under less pressure of time."

ADB also states that for other types of care home a judgement should be made as to whether PHE or a simultaneous evacuation strategy is appropriate and that "Whatever approach is adopted in the design of a building this must be recorded and communicated to the building management to ensure that procedures are adopted that are compatible with the building design." This illustrates the extent to which design for accessibility and inclusion require inclusive management if the long term objectives of the legislation are to be achieved. In addition to residential and care homes, PHE can now be part of the strategy for escape from many other types of buildings.

Second, on the subject of vertical escape, ADB refers to the importance in multi-storey buildings of the availability of a sufficient number of adequately sized and protected escape stairs. However, "some people, for example those who use wheelchairs, may not be able to use stairways without assistance. For them evacuation involving the use of refuges on escape routes and either assistance down (or up) stairways, or the use of suitable lifts, will be necessary."

Refuges are described in ADB as "relatively safe waiting areas for short periods. They are not areas where disabled people should be left alone indefinitely until rescued by the fire and rescue service, or until the fire is extinguished." Each refuge "should provide an area accessible to a wheelchair of at least 900mm × 1400mm in which a wheelchair user can await assistance." Note that Approved Document Part M (ADM) shows wheelchair spaces in a cinema or theatre which are also 900mm × 1400mm but that, once in position, the space occupied by the wheelchair user is only 900mm × 1100mm, with the additional 300mm projecting into the circulation space. On the same principle and where space is very restricted, it may be possible to make a case for the safe refuge to occupy a minimum space of 900mm × 1100mm, with the 300mm circulation space over-lapping with the circulation space for the stairway or escape route. It cannot be assumed that this would be approved by the authorities and any proposals to use this arrangement would need to be agreed with Building Control or the Fire Officer at an early stage of the design.

Third, ADB states that in certain circumstances a lift may be provided as part of a management plan for evacuating people. In such cases, the lift installation may need to be appropriately sited and protected, with safety features to ensure that the lift remains usable for evacuation purposes during the fire. Guidance on the design and use of evacuation lifts is given in BS 5588-8:1999.

Access Statements

The evolution of legislation for accessibility reached a definitive stage in 2006 and 2007. Access Statements have emerged gradually into the approval process, having been recommended in "Planning and Access for Disabled People", published by ODPM in 2003, as a means of stating the philosophy and approach to inclusive design. Access Statements were then referred to in the 2004 edition of Approved Document Part M, which recommended their use at the time of an application for Building Regulations approval.

The Disability Discrimination Act of 1995 is not based on compliance with specific requirements for the physical environment. Instead, the requirement is that the provision for disabled people should be "reasonable". This means that the interpretation of good practice depends largely on judgement but, equally, should be based on an understanding of current good practice. In referring to Access Statements, Approved Document Part M, 2004, (ADM) points out that the guidance contained in the Approved Document is designed to indicate one way in which the requirements may be met. ADM also points out that there may be other, equally satisfactory, ways of meeting the requirements and that appropriate solutions to access problems may vary according to the size, nature and intended use of the building.

ADM recommends that an Access Statement should be provided to assist building control bodies in making judgements about whether the proposals are reasonable

and that the Access Statement should be provided at the time that plans are deposited, a building notice is given or details of a project are given to an approved inspector.

ADM also noted that the guidance on access in the planning system recommends provision of an Access Statement to identify the philosophy and approach to inclusive design, the key issues of the particular scheme and the sources of advice and guidance used. In due course, the Compulsory Purchase and Town Planning Act of 2005 required Design and Access Statements to be submitted with planning applications from August 2006.

CABE published guidance in 2006 on "Design and Access Statements", recommending that these should address specifically the aspects of vehicular and transport links and also of inclusive access. CABE also describes design and access statements as "documents that explain the thinking behind a planning application" and that they should show that the applicants have "thought carefully about how everyone, including disabled people, will be able to use the places they want to build".

Interpretation of the guidance varies from those who argue that a Design and Access Statement should include all the details about the design for accessibility for the project and those who consider that the statement should contain only a summary of the access provision, with the details provided in an annexe. The latter approach has distinct advantages because the Design and Access Statement need not include undue details about access and because the detailed Access Statement, when provided as an annex, can then be updated progressively from the planning application (RIBA Stage C or D) through to the application for Building Regulations approval (Stages E or F). At the Building Regulations stage the Access Statement can be accompanied by a Part M schedule in which the details of the access provision can be set out with specific references to the clauses of Approved Document M.

The test of reasonableness

When there are problems about accessibility to a service or there is a physical barrier to access, such as on a restricted site or in a historic building, the duty to make reasonable adjustments comprises a series of duties falling into three main areas which are listed in the DRC Code of Practice as follows:

- changing practices, policies and procedures
- providing auxiliary aids and services
- overcoming a physical barrier by
 - removing the feature; or
 - altering it; or
 - avoiding it; or
 - providing services by alternative methods.

The Code lists some of the factors which might be taken into account when considering what is reasonable:

- whether taking any particular steps would be effective in overcoming the difficulty that disabled people face in accessing the services in question
- the extent to which it is practical for the service provider to take the steps
- the financial and other costs of making the adjustment
- the extent of any disruption which taking the steps would cause
- the extent of the service provider's financial and other resources
- the amount of any resources already spent on making adjustments
- the availability of financial or other assistance.

Contents of this guide

This guide summarises the following:

- the legislation and its requirements
- relevant Approved Documents
- the process and procedures for designing to meet the needs of disabled people
- guidance on good practice.

Many of the ideas and observations in this book have been developed in discussions with colleagues at David Bonnett Associates and their contributions are gratefully acknowledged.

3. Stages AB: Appraisal and Design Brief

Implementing the principles of inclusive design

The process of implementing the principles of inclusive design is well illustrated by the following chart which is based on the "Commitment to Inclusive Design" published by the Disabled Persons Transport Advisory Service (DPTAC) 2005:

RIBA Stage		Deliverables
A/B Audit existing building(s) Feasibility study of client's requirements Strategic design brief	1. Access Strategy • the Access Strategy will incorporate inclusive design principles at all RIBA work stages • it will set out a process to embed and implement inclusive design principles commencing from the design brief. For small projects: • designate an Inclusive Design Champion or representative. For medium to large projects: • appoint an Access Consultant • ensure the project team and the client's appointed Access Consultant work closely together • identify key access requirements and constraints.	Access Strategy To demonstrate a commitment to including inclusive design principles To set out a process suited to the project
C/D Project brief outline and design development	2. Access Statements • incorporate key access requirements into design proposals • consult with potential users including disabled people • develop design proposals on inclusive design principles • provide an Access Statement to support outline and detailed Planning Applications.	Access Statement For planning approval
E/F Technical design and production information	3. Building Control Submission • monitor and review design development, including fixtures and fittings • ensure designers and suppliers specify products which can be used by all • provide an Access Statement to support Building Control submission for Part M approval.	Access Statement For building control approval
G/H Tender	4. Procuring Accessibility • ensure inclusive design details are incorporated into the contract documentation for the buildings, fixtures and fittings • appraise any novated design in response to access procurement.	
J/K Mobilisation and construction	5. Monitoring progress • ensure compliance with Access Statement by monitoring all key access features during the construction period.	

RIBA Stage		Deliverables
L	6. Sign-off report	Access Statement
Post practical completion	• audit completed building and check agreed standards have been met • identify post-occupancy matters for inclusion in Facilities Management Handbook and Maintenance Manuals.	For passing Access File to client
Post occupation	Ongoing • provide suitable information where necessary for staff briefings, including circulation and escape arrangements • make any adjustments necessary to meet the needs of disabled employees.	Access Review For access awareness and staff training

4. Stage C: Concept

Note that this stage is commonly associated with the submission of applications for outline planning approval, which are now normally accompanied with an Access Statement.

Planning and design brief/standards adopted

An Access Statement at this stage considers the scheme in relation to planning for accessibility, Building Regulations Part M and also the housing standards and other standards that might apply.

It identifies areas of strength and weakness and highlights issues that can be justifiably deferred to a later stage of the development.

Design details relating to such features as ramps, steps, handrails, tactile paving, street furniture, seating, cycle stands, signage, colours etc. are expected to be identified as reserve matters. These would be the subject of further design and consultations at later stages of the project.

Typical reference documents may include the following:

1. *Planning and Access for Disabled People* (2003)
 This document was published by the office of the Deputy Prime Minister to provide guidance in the delivery of inclusive environments through the Town and Country Planning system.
2. *Building Regulations Part M* (2004)
 A central aspiration for any development should be to meet and where possible exceed Part M (2004) standards. Although confirming itself to planning issues this Access Statement should be in line with the Building Regulations.
3. *Local Authority Unitary Development Plan* (UDP)
 This is the main reference for the standards to meet the requirements of the local authority, including any references to Lifetime Homes Standards and Wheelchair Housing Standards.
4. *Lifetime Homes Standards*
 Lifetime Home Standards originally developed by the Joseph Rowntree Foundation have been widely adopted by Local Authorities.
5. *Disability Discrimination Act 1995*
 The developers or others may have ongoing obligations under the DDA as landlords may have obligations as service providers where they are also providing services to the public. In the main, the Act will apply more to issues of services and information rather than building design.

Planning and design parameters for accessibility

The following are examples of the access issues which are likely to have to be considered at the stage of an application for outline or detailed planning permission:

1. Inclusive Design: the proposals should be guided by the recognition that in addition to wheelchair users and other disabled people, the main beneficiaries of accessible routes are likely to include families with children, people who are frail and elderly and people with wheeled luggage or trolleys.
2. 24-hour routes for pedestrians, including disabled people, to be step-free and with gentle gradients.
3. Seats and level resting places to be distributed at horizontal distances of not more than about 50 metres.
4. Sloping routes with gradients of 1:20 to 1:40 to have level resting places and seats at vertical rises of not more than 500mm.
5. Slopes of 1:20 or steeper to be designed as ramps with reference to the standards recommended in Approved Document Part M 2004.
6. Entrances into buildings and to lifts to be step-free and suitable for disabled people.
7. Car parking in multi-storey car parks to include grouped parking spaces for disabled people and possibly for a Shopmobility scheme.
8. External car parking spaces and pick-up/set-down points for disabled people to be distributed in groups close to the main pedestrian routes.
9. Sanitary facilities to be conveniently located, preferably available within 100 metres during normal working or shopping hours, to be supervised and to include Unisex Accessible WCs and separate facilities for baby-changing.
10. Street furniture, paving and landscape features to enhance the circulation routes, without creating barriers or hazards for disabled people.
11. The primary access routes to be clearly legible, minimising the need for elaborate signage.
12. Commitment to inclusive design
 - Defined stages for design development
 - Consultation process
 - Information and signage
 - Emergency escape
 - Management policies.

Drawings which accompany the Access Statement at the planning application stage should show the main access routes and features, preferably marked up in colour, so as to make the access proposals clearly evident.

Design guidance in BS 8300:2001

Design of buildings and their approaches to meet the needs of disabled people

This British Standard provides essential reference for anyone who wishes to understand the basis and principles for inclusive design. BS 8300 is likely to be particularly relevant at the stages of outline design and the submission of a planning application. ADM is the main reference at the stage of a submission for Building Regulations approval. The main elements of BS 8300:2001 as amended in 2005 are summarised below, with cross-referencing to ADM 2004, which is summarised in Part 5 of this guide.

Ref. BS 8300 **Ref. ADM**

4 Car parking, setting down points and garaging 1.14
 Car parking, setting down and garaging are important activities at the
 beginning and end of journeys, particularly for disabled drivers and
 passengers. Designated parking bays require space for access and transfer
 at the sides and front or rear of the vehicle (Figs 1–4). Car park entry and
 payment equipment should be usable by disabled people, preferably
 without leaving the vehicle (Fig 5).

4.1 Car parking, garaging and enclosed parking

4.2 Setting down points

5 Access routes to and around buildings 1.1
 "It is important to restrict the number of barriers, restrictions or other
 hazards that disabled people encounter on their approach to and from a
 building." Disabled people need a generous amount of space when moving
 about (Figs 6–8). Uneven surfaces, loose materials and large gaps between
 paving materials cause problems for wheelchair users, people with impaired
 vision and others.

5.1 General 1.6

5.5 Footway and footpath surfaces

5.6 Drainage gratings

5.7 Barriers, restrictions and hazards 1.38

5.8 Ramped access 1.19
 Limits for ramp gradients are shown in Table 1. Note that in ADM the
 requirements for ramps for dwellings (ADM 6.15) are different from the
 requirements for other buildings (ADM 1.26).

Factors in the design of the principal entrance:
- prominence and visual relationship of the entrance with its surroundings
- threshold to allow convenient manoeuvring for wheelchairs
- ease of operation of the principal entrance door
- minimum effective clear width through the doorway.

Entrance lobbies and manoeuvring sequences for wheelchair users (Figs 12–13)

"An entrance hall provides the first point of contact between a visitor and the resources and activities available within a building. Suitable access to a reception point and clear signs indicating routes to other parts of the building are important."

Circulation routes need to allow ease of movement (Fig 18) and provide a sense of location and direction.

7.3 Doors fitted with a closing device

The original version of BS 8300:2001 recommended that the closing force at the leading edge of a door should not normally exceed 20, with a maximum of 30N proposed for the push action on a fire escape door. This proved to be impractical, largely because a closing force of 20N was often insufficient to prevent doors from being blown open by the wind. In an amendment issued in June 2005 the recommendations were

revised to read: "For disabled people to have independent access through single or double swing doors, the opening force, when measured at the leading edge of the door, should be not more than 30N from 0° (the door in the closed position) to 30°, and 22.5N from 30° to 60° of the opening cycle."

8	Vertical circulation	3.17

8.1 Internal steps and stairs 3.50

"People with impaired sight risk tripping or losing their balance if unaware of steps or a flight of stairs." A warning underfoot "that there is a change in level is essential."
"For steps to be comfortable to use, the rise and going need to reflect stride length while keeping within dimensional limits." (Fig 19)

8.2 Internal ramps 3.52

Key issues are the gradients of flights and the distances between landings and no individual flight should have a length of more than 10m or a rise of more than 500mm (Table 3)

8.3 Handrail design (see 5.10) 3.54

8.4 Lifts 3.21–49

Platform lift minimum dimensions: 1050mm wide × 1250mm long (but ADM 3.43g allows 800 × 1250, 900 × 1400 and 1100 × 1400mm in specified conditions)
Passenger lift minimum dimensions 1100 × 1400mm and a lift car 1500mm deep will accommodate most scooters (Table 4)

8.5 Escalators and passenger conveyors

9 Surfaces and communication aids 4.31–36

9.1 Surface finishes

Floor, wall, door and ceiling surfaces influence the ability of disabled people to use buildings independently by:
• colour, luminance and texture of surfaces
• elements such as doors, architraves, handrails etc.
• clarification of location, direction, objects etc.
• acoustic environment
• the grip of floor surfaces, particularly at changes of level

9.2 Signs and information

Information may be visual, audible or tactile. As no single medium can communicate to everyone, alternative formats and duplication are usually required (Figs 20 and 21; Tables 5 and 6)

13 Building types

13.1 Transport-related buildings
 Journeys on public transport involve people transferring between different
 modes of transport. Information systems are crucial. Guidance is provided
 for:
 • railway, bus and coach stations
 • underground railway and rapid transit stations
 • airports and terminals
 • sea terminals
 • motorway services.
 (See also other guidance for transport, e.g. Strategic Rail Authority etc.)

13.2 Industrial buildings (See sections 4–12 generally)
 Access routes for disabled people should not be reduced by safety guarding
 etc. Access routes for vehicles should be clearly marked.

13.3 Administrative and commercial buildings
 Disabled people need access to all spaces and fittings, whether as members
 of the public or as staff. Guidance for a range of building types.

13.4 Health and welfare buildings
 Guidance for:
 • hospitals
 • health centres
 • doctors' and dentists' surgeries
 • opticians
 • older persons' day centres.

13.5 Refreshment buildings, including public houses, restaurants and cafes
 All refreshment areas in the same storey should be on the same level,
 wherever possible. Any split levels should be linked by ramps.

13.6 Entertainment-related buildings (Figs 66 and 67).

13.7 Sports-related buildings
 Disabled spectators should be provided with a choice of vantage points.

13.8 Religious buildings
 Disabled people require the same degree of access to religious buildings as
 non-disabled people.
 Guidance for:
 • places of worship and meeting rooms
 • crematoria – "Wheelchair users are often placed inappropriately at the
 front of the building close to the coffin, even when they are not family
 members."

13.9 Educational, cultural and scientific buildings
Guidance for:
- universities, colleges and schools
- public and academic libraries
- laboratories
- museums and art galleries
- exhibition centres
- research, scientific and professional institutes.
(Refer to Speciall Needs and Disability Act, SENDA, 2001)

13.10 Historic buildings
Ref. "Easy access to historic buildings" (2004) and "Easy access to historic landscapes" (2005), English Heritage.

13.11 Travel and tourism-related buildings
Many disabled people travel on business and for enjoyment but it is often difficult to find suitable accommodation. Access issues apply to facilities such as:
- hotels, motels, hostels and residential clubs
- bed and breakfast guest accommodation
- self-catering holiday accommodation
- accommodation providing holiday care.

14 Residential accommodation (not included in BS 8300)
Access to and into the dwelling
Circulation within the entrance storey of the dwelling
Accessible switches and socket outlets.

15 Fire protection and emergency escape (ref. Approved Document B, Fire Safety etc.).

Annexes to BS 8300

Annex A Development of access legislation
Annex B Space allowances for people passing on an access route (Fig B1)
Annex C Slip potential characteristics of tread and floor finishes (Fig C1)
Annex D Reach ranges (Table D1; Figs D1–D4)
Annex E Space allowances (Tables E1–E17; Figs E1 and E2)
Annex F Management and maintenance issues

5. Stages DE: Design Development and Technical Design

At this stage, the requirements of Part M of the Building Regulations need to be taken into account. Approved Document Part M 2004, (ADM) is the key reference to designing for access and inclusivity at these stages and provides recommendations about how to meet the requirements of Part M.

The following charts provided a succinct summary of the recommendations of ADM, together with comments about the implications of these recommendations and of possible alternative solutions.

Key to references

ADM – Approved Document Part M 2004
BS 8300 – Design of buildings and their approaches to meet the needs of disabled people (BS 8300:2001)
DfA – Designing for Accessibility, CAE/RIBAE 2004

Access to buildings other than dwellings

References: BS 8300, Clause 5.1–6; DfA Figs 4–11

ADM: 1.1–5

Objectives
The aim is to provide a suitable means of access for people from the entrance point at the boundary of the site, and from any car parking that is provided on the site, to the building. It is important that routes between buildings within the complex are also accessible

Level approach from the boundary of the site and car parking

ADM: 1.6–12

Design considerations
Level access if possible from site boundary and car park; gentle gradient if necessary, ramped if 1:20 or more; safe and firm surfaces for access route; space for people to travel and pass; surface widths 1200–1800mm; reduce risks, particularly for people with impaired vision

ADM: 1.13

Paths within boundary property
Provisions (unless otherwise justified in an Access Statement):
a. surface width at least 1.5m wide, free of obstruction to a height of 2.1m

> **Recommendations for current good practice**
> Paths should normally have a clearly defined edge (BS 8300/5.5)

b. passing places at least 1.8m wide and at least 2m long, within sight of each other (the width of the passing place may be included in the width of the level approach) but spaced at not more than 50m

> **Recommendations for current good practice**
> Resting places at 50m intervals (BS 8300/5.1) or less where there are significant gradients

c. gradient along its length to be not steeper than 1:60 for whole length, or less steep than 1:20 with level landings (see 1.26k) for each 500m rise of the access, in all cases with a cross fall gradient no steeper than 1:40

Recommendations for current good practice
In practice a gradient of 1:40 is likely to be indistinguishable from a gradient of 1:60

d. surface to be firm, even and slip resistant, with undulations not exceeding 3mm under a 1m straight edge. Inappropriate materials might be loose sand or gravel
e. different materials along the access route to have similar frictional characteristics
f. difference in level at joints between paving units to be no greater than 5mm, with joints filled flush or, if recessed, no deeper than 5mm and no wider than 10mm or, if unfilled, no wider than 5mm

Recommendations for current good practice
Joints in paving can be hazardous for people who use sticks or crutches and very uncomfortable for wheelchair users

g. the route to the principal entrance (or alternative accessible entrance) to be clearly identified and well lit
h. the danger of walking into a vehicular route to be minimised by providing a separate pedestrian route and, where there is an uncontrolled crossing point across the vehicular route, this is to be identified by a buff coloured blister surface (see Diagram 1, and "Guidance on the use of Tactile Paving Surfaces")

Recommendations for current good practice
Ref. "Guidance on the use of Tactile Paving Surfaces"; BS 8300/5.6 recommends that tactile paving "should be used sparingly and only after consultation with user groups representing visually impaired people." Tactile paving is uncomfortable for wheelchair users and for some ambulant disabled people so, on the principles of inclusive design, should only be used where essential

On-site car parking and setting down

References: BS 8300/4.1–2; DfA Figs 1–3

ADM: 1.14–17

Design considerations

Space to park, to enter/leave vehicle at sides and rear and to travel with a wheelchair, pushchair or luggage etc. to the building entrance; parking bays to have suitable surface without hazards; if tickets required for parking, any ticket machines to be easily accessible

ADM: 1.18

Provisions (unless otherwise justified in an Access Statement):

a. at least one parking bay designated for disabled people to be provided on firm and level ground as close as feasible to the principal entrance to the building

> **Recommendations for current good practice**
> The allocation of bays for disabled employees is a management decision
> The ratio of provision may need to be increased where a greater proportion of disabled visitors is likely – e.g. day centre

b. the dimensions of the designated parking bays to be as shown in Diagram 2 (with a 1200mm accessibility zone between, and a 1200mm safety zone on the vehicular side of, the parking bays and with a dropped kerb when there is a pedestrian route at the other side of the parking bay)

> **Recommendations for current good practice**
> It may sometimes be reasonable to provide a 1200mm accessibility zone between each pair of parking bays to save space. In this situation, the vehicle can enter the bay forwards or backwards so that the accessibility zone is on the side of the vehicle which is most convenient for the disabled person

c. surface of the accessibility zone to be firm, durable and slip resistant with undulations not more than 3mm under a 1m straight edge for formless materials. Inappropriate materials might be loose sand or gravel
d. ticket machines, where necessary for wheelchair users and people of short stature, to be adjacent to the designated parking bays for disabled people and have controls at 750–1200mm above the ground and a plinth which does not project in front of the face of the machine in a way that prevents its convenient use

> **Recommendations for current good practice**
> Not applicable if disabled people do not need to use the ticket machines

e. a clearly sign-posted setting down point to be located on firm and level ground as close as practical to the principal or alternative accessible entrance with its surface level with the carriageway at that point to allow convenient access to and from the entrance for people with walking difficulties or people using a wheelchair

> **Recommendations for current good practice**
> See BS 8300/9.2–4

Ramped access

References: BS 8300/5.8; DfA Figs 15–18

ADM: 1.19–25

Design considerations

Ramps to be provided if gradient 1:20 or steeper; ramps beneficial to wheelchair users and people pushing prams, pushchairs and bicycles; gradients to be as shallow as practical but a gradient steeper than recommended may be necessary for a short distance and to be justified in an Access Statement; beneficial for some people with restricted mobility to provide steps as well as a ramp; some people need to be able to stop frequently, e.g. to regain strength or breath, or to ease pain; wheelchair users need space to stop at landings, and to open and pass through doors; support at both sides of ramp helps people with weakness at one side; if total height of ramp is too high it can be unacceptably tiring for wheelchair users and some people with walking difficulties

ADM: 1.26

Provisions (unless otherwise justified in an Access Statement):

a. readily apparent or clearly sign-posted
b. gradient of a ramp flight and its going between landings to be as Table 1 and Diagram 3

> **Recommendations for current good practice**
> Examples: 1:20 – 10 metres max; 1:15 – 5 metres max; 1:12 – 2 metres max

c. no flight to have a going greater than 10m or a rise of more than 500mm
d. alternative means of access for wheelchair users, e.g. a lift, when the total rise is greater than 2m
e. surface width between walls, upstands or kerbs to be at least 1.5m
f. ramp surface to be slip resistant, especially when wet, and of a colour that contrasts visually with that of the landings

> **Recommendations for current good practice**
> It may be reasonable for the ramp and the landings to have the same surface, particularly in historic or other sensitive settings

g. frictional characteristics of ramp and landing to be similar
h. landing at foot and head of ramp at least 1.2m long and clear of door swings and other obstructions
i. any intermediate landings to be at least 1.5m long and clear of door swings and other obstructions
j. intermediate landings at least 1800mm wide and 1800mm long as passing places when it is not possible for a wheelchair user to see from one end of the ramp to the other or the ramp has three flights or more
k. all landings to be level, subject to maximum gradient of 1:60 along the length and maximum cross fall of 1:40
l. handrail on both sides
m. kerb on open side of ramp or landing at least 100mm high with visual contrast in addition to any guarding required under Part K
n. clearly sign-posted steps, in addition, when the ramp rise is greater than 300mm (= 2 × 150mm steps)

Stepped access
References: BS 8300/5.9; DfA Figs 15–18

ADM: 1.27–32

Design considerations
Risks at steps for people with impaired vision, especially if no warning at top of steps; warning should be placed in advance of the hazard and not be so narrow as to be missed; treads should not be a slip hazard, especially when wet; benefits of highlighting nosings and avoiding open risers; projecting or excessive rounding of nosings can cause problems; advantages if dimension of treads allow feet to be placed square on; steps with easy going may allow people to rest at any point of the flight; steps are easier than ramps for many ambulant disabled people and handrails are essential

ADM: 1.33

Provisions (unless otherwise justified in an Access Statement):
a. level landing at top and bottom of each flight
b. unobstructed length of each landing not less than 1200mm
c. "corduroy" hazard warning at top and bottom landings, 800mm deep, spaced 400mm from steps (Diagram 4)

> **Recommendations for current good practice**
> Corduroy hazard warnings should be provided only where necessary, and these may not be necessary at the bottom of stairs: note the different recommendations for internal stairs (3.50–51)

d. where there is side access onto an intermediate landing, to have a "corduroy" hazard warning surface 400mm deep either on the intermediate landing 400mm from both upper and lower flights, if there is sufficient space to accommodate the surface outside the line of the side access, or within the side access 400mm from the intermediate landing if there is a continuous handrail opposite the side access
e. no doors swing across landings
f. flights to have not less than 1.2m between enclosing walls, strings or upstands
g. no single steps
h. rise of a flight between landings to be not more than 12 risers for a going of less than 350mm and 18 risers for a going of 350mm or greater

> **Recommendations for current good practice**
> Compare with internal stairs (3.51b)

i. nosings to be made apparent by a permanent contrasting material 55mm wide on both tread and riser

> **Recommendations for current good practice**
> 55mm strips on risers can be confusing for people walking up steps and the projection of the step nosing may provide sufficient contrast of colour and tone to guide people with impaired vision; good illumination can greatly improve the visibility of steps and nosings

j. projection of a step nosing to be avoided but, if necessary, to be not more than 25mm (Diagram 6)

k. rise and going of each step to be consistent throughout flight
l. rise of each step to be 150–170mm except adjacent to existing buildings where, due to dimensional constraints, the case for a different rise is argued in the Access Statement
m. going of each step to be 280–425mm
n. risers not open

> **Recommendations for current good practice**
> If open risers are required, for example to retain visibility through the staircase, an upstand of about 25mm can help visually impaired people to feel the back of the tread with a toe while walking up the steps

o. continuous handrail on each side of flight and landings
p. additional handrails to divide flight into channels not less than 1m wide and not more than 1.8m

> **Recommendations for current good practice**
> In some situations it may be reasonable to allow wider channels, for example if large numbers of people may be moving up and down the flight at the same time

Handrails to external stepped and ramped access

References: BS 8300/5.10; DfA Fig 19

ADM: 1.34–36

Design considerations
Handrails to be easy to grip, comfortable to touch and preferably provide forearm support; handrails to have clear space and rigid support without impeding finger grip; handrails to be at suitable heights for all users, to project at top and bottom of flight of steps or ramp, possible with second handrail for use by children or people of short stature

ADM: 1.37

Provisions (unless otherwise justified in an Access Statement):
a. vertical height to the top of the upper handrail from the pitch line of the surface of a ramp, or a flight of steps, to be 900–1100mm (Diagram 5)
b. where there is full height structural guarding, the vertical height to the top of any second lower handrail from the pitch line of the surface of a ramp, or a flight of steps, to be 600mm

> **Recommendations for current good practice**
> A second lower handrail can be useful where there may be children and other small visitors

c. continuous across the flights and landings of ramped or stepped access

> **Recommendations for current good practice**
> Curved joints and continuous handrails at changes of level/direction are more useful than straight handrails with gaps

d. to extend at least 300mm horizontally beyond the top and bottom of a ramped access, or the top and bottom nosing of a flight or flights of steps, while not projecting into an access route

Recommendations for current good practice
See 1.37i below

e. to contrast visually with the background against which it is seen, without being highly reflective
f. surface to be slip resistant and not cold to the touch

Recommendations for current good practice
In many cases a stainless steel handrail may be the most practical and durable material for external handrails

g. terminates in a way to reduce the risk of clothing being caught

Recommendations for current good practice
e.g. with a curve downwards or sideways

h. profile either circular with diameter 40–45mm or oval with a width of 50mm (Diagram 7)
i. to protrude not more than 100mm into the surface width of the ramped or stepped access where this would impinge on the stair width requirement of Part B1

Recommendations for current good practice
This applies particularly at half landings on fire escape stairs where the central handrail should not project 300mm in order to maintain the escape widths as in Approved Document B (ADB) Table 7

j. clearance of 60–75mm between handrail and adjacent wall surface
k. clearance at least 50mm between a cranked support and underside of handrail
l. inner face located not more than 50mm beyond the surface width of ramped or stepped access

Recommendations for current good practice
e.g. where the handrail is over a side wall or parapet

Hazards on access routes

References: BS 8300/5.7; DfA Figs 9, 11

ADM: 1.38

Design considerations
Features that occasionally obstruct an access route, e.g. windows, should not present a hazard

ADM: 1.39

Provisions (unless otherwise justified in an Access Statement):
a. where there is a projection of more than 100mm, during normal use, onto an access route, windows and doors (excluding fire escape doors) that swing outwards towards an access route, or other projecting features, are protected by guarding, which incorporates a kerb or other solid barrier that can be detected using a cane at ground level to direct people around the potential hazard (Diagram 8)
b. areas below stairs or ramps where the soffit is less than 2.1m above ground level to be protected by guarding and low level cane detection, or a permanent barrier giving the same degree of protection

Access into buildings other than dwellings

References: BS 8300, Clause 6.1–2

ADM: 2.1–3

Objectives
The aim for all new buildings is for the principal entrance or entrances and any main staff entrance, and any lobbies, to be accessible and to reduce the risks to people when entering the building

ADM: 2.4–6

Design considerations
If a main entrance cannot be accessible, consider an alternative entrance; accessible entrances to be clearly sign-posted, without hazards; level thresholds are preferred

ADM: 2.7

Provisions (unless otherwise justified in an Access Statement):
a. to be clearly sign-posted incorporating the International Symbol of Access, from the edge of the site, and from the principal entrance (if this is not accessible)
b. to be easily identified among the other elements of the building and the immediate environment, e.g. by lighting and/or visual contrast
c. any structural supports at the entrance should not present a hazard for visually impaired people
d. to have a level landing at least 1500 × 1500mm, clear of any door swings, immediately in front of the entrance and of a material that does not impede the movement of wheelchairs
e. the threshold to be level or, if a raised threshold is unavoidable, to have a total height of not more than 15mm, a minimum number of upstands and slopes, with any upstands higher than 5mm chamfered or rounded

f. any door entry systems to be accessible to deaf and hard of hearing people, and people who cannot speak

> **Recommendations for current good practice**
> Ref. DfA Fig Fig 21

g. weather protection to be provided at manual non-powered entrance doors
h. internal floor surfaces adjacent to the threshold to be of materials that do not impede the movement of wheelchairs, e.g. not coir matting, and changes in floor material not to create a potential trip hazard

> **Recommendations for current good practice**
> The main wheels of a standard manual wheelchair have a circumference of about 2000mm, therefore any matting which is intended to dry or clean these wheels should be at least 2000mm long

i. where mat wells are provided, the surface of the mat to be level with the adjacent floor finish
j. where provided as an alternative accessible entrance, an accessible internal route to be provided to the spaces served by the principal or main staff entrance

> **Recommendations for current good practice**
> This route should be suitable for people with impaired vision as well as for people with impaired mobility

Doors to accessible entrances

References: BS 8300/6.3–5; DfA Figs 20–26

ADM: 2.8–12

Design considerations
Doors to accessible entrances to be accessible to all, with manual or power operation and able to be closed when not in use; an entrance door capable of resisting wind forces is unlikely to be openable by some people, particularly those with limited strength; powered doors have many advantages, particularly automatic sliding doors; doors to accessible entrances to be wide enough for a variety of users, possibly including double buggies; people to be able to see others approaching from the opposite direction

ADM: 2.13

Provisions (unless otherwise justified in an Access Statement):
a. where required to be self-closing, a power operated door opening and closing system to be used when through calculation and experience it appears that it will not be possible otherwise for a person to open the door using a force no greater than 20N at the leading edge

> **Recommendations for current good practice**
> In practice, doors which require an opening force of only 22.5–30N are liable to blow open; power assisted opening, for use only when required and activated by a push pad, may be sensible (see ADM 2.21 and BS 8300, para 7.1, amended 2005)

b. the effective clear width through a single leaf door, or one leaf of a double door, to be in accordance with Table 2 and the rules for measurement to be in accordance with Diagram 9

> **Recommendations for current good practice**
> Note the different method for measuring the opening widths of doors to dwellings (ADM 6.23)

c. unless it can be argued otherwise in the Access Statement, e.g. for reasons of security, door leaves, and side panels wider than 450mm, to have vision panels towards the leading edge of the door whose vertical dimensions include at least the minimum zone, or zones, of visibility between 500mm and 1500mm from the floor, if necessary interrupted between 800mm and 1150mm above the floor, e.g. to accommodate an intermediate horizontal rail (see Diagram 9)

Manually operated non-powered doors

References: BS 8300/6.3–5; DfA Figs 23, 26, 27

ADM: 2.14–16

Design considerations

Disadvantages of self closing devices on manually operated doors; space at leading edge helps wheelchair users to open the door; door furniture on non-powered doors to be easy to operate

ADM: 2.17

Provisions (unless otherwise justified in an Access Statement):

a. the opening force at the leading edge of the door to be no greater than 22.5–30N

> **Recommendations for current good practice**
> See ADM 2.13 and BS 8300, para 7.1, amended 2005

b. an unobstructed space of at least 300mm on the pull side of the door between the leading edge of the door and any return wall, unless the door is a powered entrance door (see Diagram 9)
c. where fitted with a latch, the door opening furniture to be able to be operated by a closed fist, e.g. a lever handle
d. all door opening furniture to contrast visually with the surface of the door and not cold to touch

Powered entrance doors

References: BS 8300/6.3–5; DfA Figs 25–27 and "Powered doors"

ADM: 2.18–20

Design considerations

Powered door systems to be able to suit the needs of people who cannot react quickly; manual controls for powered doors to be designed and located to minimise risks for users; revolving doors are not considered accessible and an adjacent pass door to be provided

ADM: 2.21

Provisions (unless otherwise justified in an Access Statement):

a. sliding, swinging or folding action to be controlled
 - manually by a push pad, card swipe, coded entry, or remote control or
 - automatically by a motion sensor or other proximity sensor, e.g. a contact mat
b. when installed, automatic sensors to be set so that automatically operated doors open early enough, and stay open long enough, to permit safe entry and exit

> ### Recommendations for current good practice
> BS EN 81-70 recommends that the door dwell time is normally 2–20 seconds, with a sensor to prevent physical contact between the user and the leading edge of the closing door; for lifts to dwellings ADM 9.7g recommends minimum dwell times of 3–5 seconds

c. when they are swing doors that open towards people approaching the doors, visual and audible warnings to be provided to warn people of their automatic operation when both opening and shutting
d. to incorporate a safety stop that is activated if the doors begin to close when a person is passing through

> ### Recommendations for current good practice
> Ensure that fingers cannot be trapped on the hinge side of an opening or closing door

e. to revert to manual control or fail safe in open position in the event of power failure
f. when open, not to project into any adjacent access route
g. any manual controls for powered doors to be located at 750–1000mm above floor level, operable with a closed fist and, when on the opening side of the door, to be set back 1400mm from the leading edge of the door when fully open and to contrast visually with the background against which they are seen

> ### Recommendations for current good practice
> The recommended set back of 1400mm is excessive in many situations and a set back of about 500mm might often be more reasonable if there is a clear space for a wheelchair

Glass entrance doors and glazed screens

References: BS 8300/6.4.4; DfA Fig 25

ADM: 2.22–23

Design considerations

Manifestation can help people to differentiate between doors and glazed screens; door to be apparent when closed or open

> **Recommendations for current good practice**
> Note: ADM takes priority over ADN (Glazing)

ADM: 2.24

Provisions (unless otherwise justified in an Access Statement):

a. manifestation at two levels, 850–1000mm and 1400–1600mm

> **Recommendations for current good practice**
> Manifestation may not be necessary if it is visually evident that the floor surface does not continue on the other side of the glass, e.g. a glazed lift shaft

b. manifestation as a logo or sign at least 150mm high or a decorative feature at least 50mm high

> **Recommendations for current good practice**
> The visibility of manifestation depends largely on illumination and the background against which the glass is seen. There are many design options and it may be sensible to postpone the final decisions about manifestation until the completion stages of work on site

c. clear differentiation of glazed entrance doors from glazed screen

> **Recommendations for current good practice**
> Door frames may provide adequate differentiation between glazed doors and screens

d. glass entrance doors, where capable of being held open, protected to prevent leading edge constituting a hazard

Entrance lobbies

References: BS 8300/6.36; DfA Fig 22

ADM: 2.25–28

Design considerations

Lobby function is to limit air infiltration, maintain comfort, increase security, provide transitional lighting; lobby to provide space for wheelchair users, prams etc.; minimise potential hazards, distracting reflections etc.; prevent rainwater being taken into the building and becoming a slip hazard

ADM: 2.29

Provisions (unless otherwise justified in an Access Statement):

a. length with single swing doors to be in accordance with Diagram 10
b. length with double swing doors as the formula (DP1 + DP2 + 1570mm)

Recommendations for current good practice

See ADM Diagram 10 for key dimensions for lobbies

c. width (excluding any projections into the space) to be at least 1200mm or as the formula (DL1 or DL2 + 300mm) whichever is the greater when single leaf doors are used and at least 1800mm when double leaf doors are used
d. glazing within the lobby not to cause distracting reflections
e. the floor surface materials within the lobby not to impede the movement of wheelchairs, e.g. not coir matting, and changes in floor materials not to create a potential trip hazard
f. the floor surface to remove rainwater from shoes and wheelchairs

Recommendations for current good practice

To avoid the floor in the entrance lobby becoming slippery; the circumference of the main wheels of a typical wheelchair is about 2000mm, therefore an entrance mat should be at least this length to clean and dry the wheels

g. where mat wells are provided, the surface of the mat well to be level with the surface of the adjacent floor finish
h. any columns, ducts and similar full height elements that project into the lobby by more than 100mm to be protected by a visually contrasting guard rail

Horizontal and vertical circulation in buildings other than dwellings

References: BS 8300/7, 8, 9

Entrance hall and reception area

ADM: 3.1

Objective

All people to travel vertically and horizontally within buildings conveniently and without discomfort in order to make use of all relevant facilities

ADM: 3.2–5

Design considerations

Reception area to be easily accessible and convenient to use; any reception or sales counter to have convenient access, with part at a level suitable for a wheelchair user or seated person; glazed screens in front of reception point, or light sources behind, could make it difficult for a person with impaired hearing to lip read or follow sign language; information about the building should be available from reception point, notice boards or signs

> **Recommendations for current good practice**
> BS 8300/7.1, DfA Figs 28, 37, 38

ADM: 3.6

Provisions (unless otherwise justified in an Access Statement):

a. any reception point located away from principal entrance but with a view of it

> **Recommendations for current good practice**
> CCTV monitors can provide views of the entrance area if necessary

b. any reception point easily identifiable and approach direct and free from obstructions
c. space for wheelchair users to gain access to reception point

> **Recommendations for current good practice**
> Note seating recommendations in 4.5–11;
> seats height 450–500mm and with armrests

d. clear manoeuvring space in front of reception desk 1200 deep × 1800mm wide if there is knee recess 500mm deep
e. any reception desk or counter to be designed to accommodate standing or seated visitors, with one section at least 1500mm wide, surface not higher than 760mm and knee recess not less than 700mm above floor level

> **Recommendations for current good practice**
> Note that for counters with a simple transaction, such as a bar where people order drinks etc., it may be reasonable to omit the knee space

f. any reception point to have a hearing enhancement system, e.g. induction loop
g. floor surface to be slip resistant

> **Recommendations for current good practice**
> BS 8300/9.1.3 and Annex C

Internal doors

ADM: 3.7–9

Design considerations

Since doors are potential barriers, their use should be avoided wherever possible; uses of self-closing devices should be minimised (ref 2.14); advantages of electric powered hold-open devices; low energy powered door systems are slow; doors should be apparent to visually impaired people whether open or closed

> **Recommendations for current good practice**
> BS 8300/6.4
> ADM 2.14-17
> DfA "Internal doors"

ADM: 3.10

Provisions (unless otherwise justified in an Access Statement):

a. if to be opened manually, opening force at leading edge not to exceed 20N
b. effective clear width through a single door or one leaf of a double door to be as Table 2 and Diagram 9

> **Recommendations for current good practice**
> See the different method of measurement for door openings to dwellings (ADM 6.23 and BS 8300, para 7.1, amended 2005)

c. unobstructed spaces of at least 300mm on pull side of door (unless power-controlled opening or access to a standard hotel bedroom)

> **Recommendations for current good practice**
> For doors to standard and wheelchair accessible bedrooms ref. para. 4.24

d. where fitted with a latch, latch to be operated with a closed fist, e.g. a lever handle
e. all door furniture to contrast visually with door surface
f. door frames to contrast visually with surrounding wall

> **Recommendations for current good practice**
> The visibility of doors can be adequate without contrasts of colour or tone if there are strong shadows on the doorway, e.g. with timber panelling if this is well illuminated

g. the surface of the leading edge of any door that is not self-closing, or is likely to be held open, to contrast visually with the other door surfaces and its surroundings
h. where appropriate in door leaves or side panels wider than 450mm, to have vision panels towards the leading edge of the door whose vertical dimensions include at least the minimum zone, or zones, of visibility between 500mm and 1500mm from the floor, if necessary interrupted between 800mm and 1150mm above the floor, e.g. to accommodate an intermediate horizontal rail (see Diagram 9)

> **Recommendations for current good practice**
> This applies for doors in frequent use. Vision panels from 500mm enable children, and people who are small or in wheelchairs, to see and be seen; vision panels are particularly important for doors to refreshment areas where people may be carrying drinks or food

i. when of glass, to have clear manifestation at two levels, 850–1000mm and 1400–1600mm

> **Recommendations for current good practice**
> See note to ADM 2.24b

j. when of glass or fully glazed, to be clearly differentiated from adjacent glazed wall or partition
k. fire doors, particularly in corridors to be held open with an electro-magnetic device, but self-close when:
 * activated by smoke detectors etc.
 * power supply fails
 * activated by a hand-operated switch

> **Recommendations for current good practice**
> Doors which have to be opened are an obstacle for many people – when the doors are held open by an electromagnetic fitting this obstacle is removed

l. fire doors, particularly in individual rooms, to be fitted with swing-free devices that close when activated by smoke detectors, fire alarm system or when power supply fails
m. any low energy powered swing door system to be capable of being operated in manual mode, in powered mode or in power-assisted mode

Corridors and passageways

ADM: 3.11–13

Design considerations
Corridors and passageways should be wide enough to allow people with buggies, cases or crutches or wheelchairs to pass each other and, where necessary, to turn 180°; visual contrasts of wall/ceiling, wall/floor finishes and lighting can help people with visual impairment; good acoustic design helps with communication and conversation

> **Recommendations for current good practice**
> BS 8300/7.2–3
> DfA Fig 29 and "Surfaces"

ADM: 3.14

Provisions (unless otherwise justified in an Access Statement):
a. elements such as columns, radiators, fire hoses not to project into corridor or to have a means of directing people around them
b. unobstructed width (excluding any projections) at least 1200mm
c. where unobstructed width is less than 1800mm, to have passing places at least 1800mm long and 1800mm wide at reasonable junctions

> **Recommendations for current good practice**
> Passing places should generally be within sight of each other; corners and junctions of corridors can serve as passing places

d. floor to be level (or not steeper than 1:60) with any section with a gradient of 1:20 or steeper to be designed as a ramp as Table 1 and Diagram 3

e. where a section of the floor has a gradient steeper than 1:60 but less steep than 1:20, to rise not more than 500mm without a level resting place at least 1500mm long

f. any sloping section to extend the full width of the corridor or, if not, the exposed edge to be clearly identified by visual contrast and, where necessary, by guarding

g. any door opening towards a corridor which is a major access route or an escape route, to be fully recessed so that, when fully open, it does not project into the corridor space, except where the doors are to minor utility facilities, such as small store rooms and locked duct cupboards

h. any door from a unisex wheelchair-accessible toilet may project into a corridor if not a major access route or escape route at least 1800mm wide

i. on a major access route or an escape route the wider leaves of unequal double doors to be consistently on the same side of the corridor

j. floor surface finishes that could be mistaken for steps or changes of level to be avoided

Recommendations for current good practice
Floor patterns can be confusing for people with impaired vision and, as an extreme example, can be particularly confusing for people with dementia and similar problems

k. floor finishes to be slip resistant

l. any glazed screens to have clear manifestation at two heights, 850–1000mm and 1400–1600mm

Recommendations for current good practice
See ADM 2.24b

Internal lobbies

ADM: 3.15 **Design considerations**
A wheelchair user, with or without a companion, or a person with a pram or buggy, should be able to move clear of one door before attempting to open a second door

Recommendations for current good practice
BS 8300/6.36

ADM: 3.16 **Provisions (unless otherwise justified in an Access Statement):**
a. length with single swing doors to be as Diagram 10

Recommendations for current good practice
See 2.29a

b. length with double doors as formula

Recommendations for current good practice
See 2.29a

c. width as formula

> **Recommendations for current good practice**
> See 2.29a

d. glazing not to cause distracting reflections
e. any junction of floor finishes not to create a trip hazard
f. any columns, ducts etc. that project by more than 100mm to be protected

Vertical circulation within the building

ADM: 3.17–20

Design considerations
A passenger lift is preferred over other options for vertical circulation although other options may have to be considered; signs should indicate location of lift and the floor level reached at each landing; internal stairs should be provided as an alternative means of vertical access and be designed to suit ambulant disabled people and those with impaired sight; a ramp may be provided on an internal circulation route to a lift if a change of level is unavoidable

> **Recommendations for current good practice**
> BS 8300/8.1–5

Provision of lifting devices

ADM: 3.21–23

Design considerations
For all buildings a passenger lift is the most suitable form of access between storeys; a platform lift may be an alternative, but less satisfactory, option; exceptionally, in existing buildings, a wheelchair platform lift may be considered and its use argued in an Access Statement

> **Recommendations for current good practice**
> BS 8300/8.4–5

ADM: 3.24

Provisions (unless otherwise justified in an Access Statement):
a. new developments to have a passenger lift serving all storeys
b. new developments, where due to site constraints a passenger lift cannot be accommodated to provide access to persons with impaired mobility, to have a lifting platform of a type designed for the vertical height to be travelled
c. existing buildings to have a passenger lift serving all storeys or, if a passenger lift cannot reasonably be accommodated to provide access to person with impaired mobility, to have a lifting platform of a type designed for the vertical height to be travelled
d. existing buildings to have a wheelchair platform stairlift, serving an intermediate level or a single storey, only in exceptional circumstances

General requirements for lifting devices

ADM: 3.25–27 **Design considerations**
Lifting device to be fit for purpose (see references); illumination in lift car, on lifting platform or on wheelchair platform stairlift to minimise glare, reflection, confusing shadows or pools of light and dark; all users to be able to reach and use the controls

> **Recommendations for current good practice**
> BS 8300/8.4–5

ADM: 3.28 **Provisions (unless otherwise justified in an Access Statement):**
a. an unobstructed manoeuvring space of 1500mm × 1500mm, or a straight access route 900mm wide, in front of each lifting device
b. the landing call buttons to be located at 900–1100mm from the floor of the landing and at least 500mm from any return wall
c. the landing call button symbols, where provided, and lifting device control button symbols to be raised to facilitate tactile reading

> **Recommendations for current good practice**
> Embossed buttons which can be read by sight or by touch are useful to more people, and therefore more inclusive, than buttons with Braille

d. all call and control buttons to contrast visually with the surrounding face plate, and the face plate similarly to contrast with the surface on which it is mounted
e. the floor of the lifting device should not be of a dark colour and should have frictional qualities similar to, or higher than, the floor of the landing

> **Recommendations for current good practice**
> A dark floor can give the impression of being an open lift shaft

f. a handrail to be provided on at least one wall of the lifting device with its top surface at 900mm (nominal) above the floor and located so that it does not obstruct the controls or the mirror

> **Recommendations for current good practice**
> See ADM 3.34d

g. a suitable emergency communication system to be fitted

Passenger lifts

ADM: 3.29–33 **Design considerations:**
lift sizes to suit anticipated use of building and needs of disabled people; minimum recommended lift car size (1100mm wide by 1400mm deep) will accommodate a wheelchair user with an accompanying person; a larger lift (2000mm wide by 1400mm deep) will carry any type of wheelchair together with several other

passengers and allow a wheelchair user or a person with a walking frame to turn through 180°; lift door systems to allow adequate time for people, and any assistance dogs, to enter or leave the lift without coming into contact with closing doors; people arriving or waiting for a lift need audible and visible information that a lift has arrived, which floor it has reached and where in a block of lifts it is located; visually and acoustically reflective wall surfaces can cause difficulties for people with visual or hearing impairment; lift cars (used for access between two levels only) may have opposing doors to allow a wheelchair user to leave without reversing out

Recommendations for current good practice
BS 8300/8.4.3
DfA Fig 30

Note that BS 8300/8.4.3 is more positive and recommends that "where a lift is used for access between two levels only, lifts with opposite doors should be used as they avoid the necessity for a wheelchair user to reverse out or turn around in the lift car"

ADM: 3.34

Provisions (unless otherwise justified in an Access Statement):
a. to conform to the requirements of the Lift Regulations 1997, S.I. 1997/831
b. to be accessible from the remainder of the storey
c. the minimum dimensions of the lift car to be 1100mm wide and 1400mm deep (Diagram 11)

Recommendations for current good practice
A key decision is about whether to provide a lift which can accommodate pavement scooters or whether the users of scooters can reasonably be expected to change to a wheelchair when inside a building

d. for lifts of a size that does not allow a wheelchair user to turn around within the lift car, a mirror to be provided in the lift car to enable a wheelchair user to see the space behind the wheelchair

Recommendations for current good practice
See ADM 3.28f

e. power-operated horizontal sliding doors to provide an effective clear width of at least 800mm (nominal)
f. doors to be fitted with timing devices and re-opening activators to allow adequate time for people and any assistance dogs to enter or leave

Recommendations for current good practice
BS EN 81-70 recommends that the door dwell time is normally 2–20 seconds, with a sensor to prevent physical contact between the user and the leading edge of the closing door; for lifts to dwellings, ADM 9.7g recommends minimum door opening times of 3–5 seconds

g. car controls to be located at 900–1200mm (preferably 1100mm) from the car floor and at least 400mm from any return wall

h. landing call buttons to be located at 900–1100mm from the floor of the landing and at least 500mm from any return wall

i. lift landing and car doors to be distinguishable visually from the adjoining walls

j. audible and visual indication of lift arrival and location to be provided in the lift car and lift lobby

k. areas of glass to be identifiable by people with impaired vision

Recommendations for current good practice
Glass enclosures to lifts may be satisfactory without manifestation in some situations, such as where the discontinuity of the floor surface and the detailing of the glazing provide adequate visual indication

l. where the lift is to be used to evacuate disabled people in an emergency, it conforms to the relevant recommendations of BS 5588-8

Lifting platforms

ADM: 3.35–42

Design considerations
To be provided only to transfer wheelchair users, people with impaired mobility and their companions vertically between levels or storeys; all users, including wheelchair users, to be able to reach and use the controls; people using or waiting for a lifting platform need audible and visual information that the platform has arrived and which floor it has reached; lifting platforms travel slowly and may not be suitable for users with certain disabilities e.g. those easily fatigued; lifting platforms are operated by continuous pressure controls which may be push buttons or another means of continuous pressure control to accommodate the needs of users with varying degrees of manual dexterity; selection of a lifting platform should take account of its intended use, particularly if in an unsupervised environment; lifting platforms may have opposing doors, when used for access between two levels only, to allow a wheelchair user to leave without reversing out; if a second door is provided at 90° to the first a wider platform would be required; visually and acoustically reflecting wall surfaces can cause discomfort for people with visual or hearing impairment

Recommendations for current good practice
BS 8300/8.4.4DfA, Figs 31, 32

ADM: 3.43

Provisions (unless otherwise justified in an Access Statement):
a. to conform to the requirements of the Supply of Machinery (Safety) Regulations 1992, S.I. 1992/3073

Recommendations for current good practice
BS 5588-8 states that lifting platforms may not be used for emergency escape

b. the vertical travel distance to be:
 i) not more than 2m, where there is no liftway enclosure and no floor penetration
 ii) more than 2m, where there is a liftway enclosure

c. the rated speed of the platform lift not to exceed 0.15m/s
d. the lifting platform controls to be located at 800–1100mm from the floor of the lifting platform and at least 400mm from any return wall
e. continuous pressure controls to be provided
f. landing control buttons to be located at 900–1100mm from the floor of the landing and at least 500mm from any return wall
g. the minimum clear dimensions of the platform to be:
 i) 800mm wide and 1250mm deep, where the lifting platform is not enclosed and where provision is being made for an unaccompanied wheelchair user
 ii) 900mm wide and 1400mm deep, where the lifting platform is enclosed and where provision is being made for an unaccompanied wheelchair user

Recommendations for current good practice
See ADM 9.7c for lift sizes for dwellings

 iii) 1100mm wide and 1400mm deep where two doors are located at 90 degrees relative to each other and where the lifting platform is enclosed or where provision is being made for an accompanied wheelchair user

Recommendations for current good practice
Note that 1100 × 1400mm is the minimum size for the car of a standard passenger lift (3.34c)

h. doors to have an effective clear width of at least 900mm for an 1100mm wide and 1400mm deep lifting platform and at least 800mm in other cases
i. fitted with clear instructions for use
j. the lifting platform entrances to be accessible from the remainder of the storey
k. doors to be distinguishable visually from the adjoining walls
l. an audible and visual announcement of platform arrival and level reached
m. areas of glass to be identifiable by people with impaired vision

Wheelchair platform stairlifts

ADM: 3.44–48

Design considerations
Intended only for wheelchair users when it is not practical to install a conventional passenger lift or lifting platform; wheelchair platform lifts travel slowly and may not be suitable for users with certain disabilities e.g. those easily fatigued; wheelchair platform lifts are operated by continuous pressure controls

Recommendations for current good practice
BS 8300/8.4.4–4.5
DfA Fig 33

ADM: 3.49

Provisions (unless otherwise justified in an Access Statement):
a. to conform to the requirements of the Supply of Machinery (Safety) Regulations 1992, S.I. 1992/3073

b. in a building with a single stairway, the required clear width of the flight of stairs and landings for means of escape to be maintained when the wheelchair is in the parked position (see also Approved Document B)
c. the rated speed of the platform not to exceed 0.15m/s
d. continuous pressure controls to be provided
e. the minimum clear dimensions of the platform to be 800mm wide and 1250mm deep
f. to be fitted with clear instructions for use
g. access with an effective clear width of at least 800mm
h. controls designed to prevent unauthorised use

Internal stairs

ADM: 3.50

Design considerations
With the exception of the need for hazard warning surfaces on landings, other design considerations are as 1.29–32; there is no recognised warning surface for use internally which can be guaranteed not to cause a trip hazard when used alongside floor surfaces with different frictional characteristics; designers should be aware of the potential risks of a stair directly in line with an access route; a going of at least 300mm is preferred for mobility impaired people

Recommendations for current good practice
BS 8300/8.1
DfA Fig 15 and "Internal stairs, ramps and handrails"

ADM: 3.51

Provisions (unless otherwise justified in an Access Statement):
a. to comply with provisions a, b, e to g, i to k and n to p of 1.33
b. a flight between landings normally to contain not more than 12 risers, but exceptionally not more than 16 risers in small premises where the plan area is restricted (Diagram 12)

Recommendations for current good practice
See ADM 1.33h for external steps and ADM 6.17 and 7.7 for steps to dwellings

c. the rise of each step to be 150–170mm, except in existing buildings where, due to dimensional constraints, the case for a different rise is argued in the Access Statement
d. the going of each step to be at least 250mm
e. the area beneath a stair where the soffit is less than 2.1m above floor level to be protected as described in 1.39b

Note: For school buildings, in respect of 3.51c and d, the rise should not exceed 170mm with a preferred going of 280mm. Also for schools, refuges should be provided for all stairs where no other arrangement is in place (see AD B, B1.xvi, and BS 5588-8 for details of refuges)

Internal ramps

ADM: 3.52

Design considerations

As items 1.19–25 generally, except for issues of external environment; because ramps may not be safe or convenient for ambulant disabled people, steps should be provided as well as a ramp unless the ramp is short, shallow and equals not more than 2 risers

Recommendations for current good practice
BS 8300/8.2
DfA Fig 15 and "Internal stairs, ramps and handrails"

ADM: 3.53

Provisions (unless otherwise justified in an Access Statement):
a. to comply with provisions a to c, e to j and l to m for ramped access in 1.26
b. where the change of level is 300mm or more, 2 or more clearly signposted steps to be provided in addition to the ramp
c. where the change of level is no greater than 300mm, a ramp to be provided instead of a single step
d. all landings to be level, subject to a maximum gradient of 1:60 along their length
e. the area beneath a ramp where the soffit is less than 2.1m above floor level to be protected as described in 1.39(b)

Handrails to internal steps, stairs and ramps

ADM: 3.54

Design considerations

As 1.34–36

Recommendations for current good practice
BS 8300/8.3
DfA Fig 15 and "Internal stairs, ramps and handrails"

ADM: 3.55

Provisions (unless otherwise justified in an Access Statement):
Handrails to internal steps, stairs and ramps to comply with all the provisions contained in 1.37

Recommendations for current good practice
See ADM 1.37i for handrail projections

Facilities in buildings other than dwellings

References: BS 8300, Clauses 10 and 11

ADM: 4.1–4

Objectives

All people to have access to, and the use of, all the facilities within the building

Recommendations for current good practice
BS 8300/10–13

Audience and spectator facilities

ADM: 4.5

Design considerations
Three categories of facilities, i.e. lecture/conference, entertainment, sports

> **Recommendations for current good practice**
> BS 8300/11.3

ADM: 4.6–8

Design considerations
For audience facilities generally: wheelchair users and those with mobility or sensory impairment may need to view or listen from a particular side, or sit in front for lip reading or to read sign interpreters; detailed considerations include choice and variety of spaces

ADM: 4.9

Design considerations
For lecture/conference facilities: people with hearing impairments to be able to participate fully in conferences, meeting rooms and study groups; detailed considerations include equipment, lighting etc.

> **Recommendations for current good practice**
> BS 8300/11.4

ADM: 4.10

Design considerations
For entertainment, leisure and social facilities: in facilities for entertainment e.g. theatres and cinemas, seating may be more closely packed than in other types of auditoria; design and choice of locations for wheelchair users etc. to ensure that all visitors enjoy the atmosphere

> **Recommendations for current good practice**
> BS 8300/13.6

ADM: 4.11

Design considerations
For sports facilities: to be used by all people independently or with companions; all public and staff areas to be accessible

> **Recommendations for current good practice**
> BS 8300/13.7

ADM: 4.12

Provisions (unless otherwise justified in an Access Statement):
For audience seating generally
a. the route to wheelchair spaces to be accessible by wheelchair users
b. stepped access routes to audience seating to be provided with fixed handrails
c. minimum number of spaces for wheelchair users to be as Table 3
d. some wheelchair spaces to be in pairs with standard seating on at least one side (Diagram 13)
e. where there are more than two wheelchair spaces, they are located to give a range of views

f. minimum clear space for access to wheelchair spaces to be 900mm
g. clear space for an occupied wheelchair to be 900mm wide by 1400mm long

> **Recommendations for current good practice**
> Diagram 15 shows the space occupied by a wheelchair user as 900mm wide by
> 1100mm long, with the additional 300mm for circulation space; these
> dimensions may also be considered when planning for safe refuges in restricted
> spaces

h. floor of each wheelchair space to be horizontal
i. some seats to be located in position suitable for an assistance dog
j. standard seats at the ends of rows and next to wheelchair spaces to have
 detachable or lift-up arms

> **Recommendations for current good practice**
> Detachable or lift-up seats can enable some wheelchair users to transfer to/from a
> standard seat

For seating on a stepped terraced floor
k. wheelchair spaces at the back of a stepped terraced floor to be as Diagrams 14
 or 15

For lecture/conference facilities
l. where there is a podium or stage, wheelchair users to have access by ramp or
 lifting platform
m. a hearing enhancement system to be in accordance with 4.36

Refreshment facilities

ADM: 4.13–15

Design considerations
To be usable by all people independently or with companions; all public and staff
areas to be accessible

> **Recommendations for current good practice**
> BS 8300/11.1–2; 12.1
> DfA Fig 37

ADM: 4.16

Provisions (unless otherwise justified in an Access Statement):
a. all users to have access to all parts of the facility
b. part of the working surface of a bar or serving counter to be at a height of not
 more than 850mm

> **Recommendations for current good practice**
> This may not be applicable if staff service is available

c. the worktop of a refreshment facility (e.g. for tea making) to be 850mm above
 floor level with a clear space beneath of at least 700mm (Diagram 16)
d. a wheelchair accessible threshold at the transition between external seating and
 interior of the facility

Sleeping accommodation

ADM: 4.17–23

Design considerations

Wheelchair users to be able to reach all facilities within the building, without disadvantageous bedroom locations etc.; detailed considerations include door sizes, sanitary facilities, space to manoeuvre and to visit other rooms etc.

Recommendations for current good practice
BS 8300/12.5
"Consideration should be given to the use of electronic card-activated locks and electrically powered openers for bedroom entrance doors" (BS 8300/12.5.4.2)

ADM: 4.24

Provisions (unless otherwise justified in an Access Statement):

For all bedrooms
a. effective clear width of door from corridor as Table 2

Recommendations for current good practice
ADM 3.10c recommends unobstructed spaces of at least 300mm on pull side of door (unless power-controlled opening or access to a standard hotel bedroom)

b. swing doors for wardrobes etc. to open through 180 degrees
c. handles on hinged and sliding doors to be easy to use and with visual contrast
d. openable windows and window controls to be 800–1000mm above floor and easy to operate
e. all bedrooms to have a visual fire alarm signal, in addition to the requirements of Part B
f. any room numbers to be embossed

Recommendations for current good practice
Embossed numerals can be read by sight or touch and are therefore more inclusive than Braille signage but should be located consistently in predictable positions

For wheelchair-accessible bedrooms
g. at least one wheelchair-accessible bedroom for every 20 bedrooms or pro rata
h. wheelchair-accessible bedrooms to be on accessible routes to all other available facilities in the building
i. wheelchair-accessible bedrooms to provide a choice of location, with a standard of amenity equal to other bedrooms
j. door from corridor to a wheelchair-accessible bedroom to be as for "Internal doors" (3.10), in particular for maximum opening force and 300mm space at leading edge of door

Recommendations for current good practice
See ADM 3.10c for access to hotel bedrooms where the occupant would normally open the door for a disabled person

k. effective clear width of any door to an en-suite bathroom or shower room within the wheelchair-accessible bedroom to comply with Table 2

> **Recommendations for current good practice**
> See ADM 3.10b and 6.23 for measurement of door opening widths

l. size of a wheelchair-accessible bedroom to allow for a wheelchair user to manoeuvre at the side of a bed, then transfer independently to it (ref. Diagram 17)

> **Recommendations for current good practice**
> The recommended spaces include a wheelchair turning space 1500 × 1500mm

m. sanitary facilities en-suite to a wheelchair-accessible bedroom to comply with 5.15–5.21
n. wide angle viewers, where provided in the entrance door to a wheelchair-accessible bedroom, to be located at 1050–1500mm above floor level
o. any balcony to a wheelchair-accessible bedroom to have an effective door width as Table 2, a level threshold and no horizontal transoms between 900 and 1200mm above the floor
p. no permanent obstructions in a zone 1500mm back from any balcony doors
q. an emergency assistance alarm (and reset button) to be located in a wheelchair-accessible bedroom, sited to be operated both from the bed and from an adjacent floor area
r. an emergency assistance call signal outside an accessible bedroom located to be easily seen by those able to assist and, in any case, at a central control point

Switches, outlets and controls

ADM: 4.25–29

Design considerations
Ease of operation, visibility, height and freedom from obstruction; consistent relationship with doorways and corners; controls to be designed to assist visually impaired people and those with limited manual dexterity

> **Recommendations for current good practice**
> BS 8300/10.5
> DfA Fig 43

ADM: 4.30

Provisions (unless otherwise justified in an Access Statement):
a. wall-mounted socket outlets, telephone points and TV sockets to be located at 400–1000mm above floor level, preferably at the lower end of the range
b. switches for permanently wired appliances to be 400–1200mm above floor level unless required at a higher level for particular appliances
c. all switches and controls that require precise hand movements to be 750–1200mm above the floor
d. simple push button controls that require limited dexterity to be not more than 1200mm above the floor

e. pull cords for emergency alarm systems to be coloured red, located as close to a wall as possible, and have two red 50mm diameter bangles, one set at 100mm and the other at 800–1000mm above the floor

f. controls that need close vision to be located at 1200–1400mm above the floor

g. socket outlets to be located consistently in relation to doorways and room corners, but no nearer than 350mm to room corners

h. light switches for use by the general public to have large push pads and align horizontally with door handles within the range 900–1100mm, for ease of location when entering a room

i. where switches described in 4.30h cannot be provided, lighting pull cords to be 900–1100mm above floor level and fitted with a 50mm diameter bangle visually contrasting and distinguishable from any emergency pull cord

j. the operation of switches, outlets and controls not to require the simultaneous use of both hands, except when necessary for safety reasons

k. switched socket outlets to indicate whether they are "on"

l. mains and circuit isolator switches to clearly indicate that they are on or off

m. front plates to contrast visually with their backgrounds

Aids to communication

ADM: 4.31–35

Design considerations

Benefits of an integrated system for wayfinding, public address and hearing enhancement; choice of floor, wall and ceiling finishes can help to reduce glare, reflections, confusing patterns etc.; public address, hearing enhancement, telephone systems and acoustic environment to ensure intelligibility; artificial lighting to give good colour rendering, without glare or pools of brightness/shadow; illumination of a face can assist with lip reading; uplighters at low level may be disorientating; enhanced levels of sound provided by induction loop, infrared, radio or sound field systems etc.

Recommendations for current good practice
BS 8300/9.1–4; 11.1–2
DfA Figs 39–42, "Lighting" and "Acoustics"
Sign Design Guide

ADM: 4.36

Provisions (unless otherwise justified in an Access Statement):

a. a clearly audible public address system to be supplemented by visual information

b. a hearing system to be installed in rooms designed for meetings, lectures, classes, performances, spectator sports or films, and at service or reception counters when situated in noisy areas or behind glazed screens

c. the presence of an induction loop to be indicated by the standard symbol

d. telephones suitable for hearing aid users to be clearly indicated by the standard ear and "T" symbol and incorporate an inductive coupler and volume control

> **Recommendations for current good practice**
> Acoustic hoods should be outside access routes, with a hazard warning

e. text telephones for deaf and hard of hearing people to be clearly indicated by the standard symbol
f. artificial lighting to be compatible with other electronic and radio frequency installations

Sanitary accommodation in buildings other than dwellings

References: BS 8300, Clauses 12.4–5

Sanitary accommodation generally

ADM: 5.1–2

Objectives
In principle, suitable sanitary accommodation should be available to everybody, including sanitary accommodation designed for wheelchair users, ambulant disabled people, people of either sex with babies and small children, or people encumbered by luggage

ADM: 5.3

Design considerations
Consider needs of people with a wide range of disabilities, including taps and WC cubicle doors to be easy to open

> **Recommendations for current good practice**
> BS 8300/12.2–4

ADM: 5.4

Provisions (unless otherwise justified in an Access Statement):
a. any bath or wash basin tap to be controlled automatically or to be capable of being operated using a closed fist, e.g. by lever action
b. terminal fittings to comply with Water Supply Regulations 1999
c. door handles and other ironmongery to comply with 3.10d and e for "Internal doors"
d. WC compartment doors, and doors to wheelchair accessible unisex toilets, changing rooms or shower rooms to be fitted with light-action privacy bolts so that they can be operated by people with limited dexterity and, if required to self-close, to be opened with a force no greater than 20N

> **Recommendations for current good practice**
> Large handles or bolts are preferable to small snib locks which require finger strength

e. WC compartment doors, and doors to wheelchair-accessible unisex toilets, changing rooms or shower rooms to have an emergency release mechanism so as to be capable of being opened outwards from the outside, in case of emergency
f. doors, when open, not to obstruct emergency escape routes
g. any fire alarm to emit a visual and audible signal to warn occupants with hearing or visual impairments

h. any emergency alarm system to have:
i) visual and audible indicators to confirm that an emergency call has been received
ii) a reset control reachable from a wheelchair and the WC, or from the wheelchair and the shower/changing seat
iii) a signal that is distinguishable visually and audibly from the fire alarm

i. any lighting controls to comply with the provisions for "Switches and controls" (4.30)

j. any heat emitters to be either screened or have their exposed surfaces at a temperature below 43° C

k. the surface finish of sanitary fittings and grab bars to contrast visually with background wall and floor finishes, with visual contrast between wall and floor finishes

Recommendations for current good practice
White fittings on white walls do not have adequate visual contrast; coloured tiles or other surfaces can assist people with impaired vision and be attractive for everyone

Provision of toilet accommodation

ADM: 5.5–6

Design considerations
Advantages of self-contained unisex toilets where someone of a different sex can give assistance; these should not be used for baby changing

Recommendations for current good practice
BS 8300/12.4
DfA Figs 34, 35

ADM: 5.7

Provisions (unless otherwise justified in an Access Statement):
a. where there is space for only one toilet in a building, it is to be of a wheelchair-accessible unisex type, but of greater width to accommodate a standing height washbasin

Recommendations for current good practice
This applies if there is only one toilet in the building – see ADM 5.10e

b. at least one wheelchair-accessible unisex toilet to be provided at each location in a building where sanitary facilities are provided for use by customers and visitors, or by people working in the building

c. at least one WC cubicle to be in separate-sex toilet accommodation for use by ambulant disabled people

Recommendations for current good practice
See 5.14b and Diagram 21 for cubicles 800mm wide

d. where there are 4 or more WC cubicles in separate-sex toilet accommodation, one of these to be an enlarged cubicle for use by people who need extra space in addition to any provision under 5.7c

Recommendations for current good practice
See 5.14d for cubicles 1200mm wide

Wheelchair-accessible unisex toilets

ADM: 5.8–9 **Design considerations**

Detailed requirements for unisex accessible WCs

> **Recommendations for current good practice**
> BS 8300/12.4.3
> DfA Fig 36

ADM: 5.10 **Provisions (unless otherwise justified in an Access Statement):**

a. one to be located as close as possible to the entrance and/or waiting area of the building
b. not located in a way that compromises the privacy of users
c. located in a similar position on each floor of a multi-storey building, and to allow for right- and left-hand transfers

> **Recommendations for current good practice**
> e.g. handed on alternate floors

d. when more than one unisex toilet is available in other than multi-storey buildings, a choice of layouts to be suitable for left-hand and right-hand transfer
e. when it is the only toilet facility in the building, the width to be increased from 1.5m to 2m and to include a standing height wash basin, in addition to the finger rinse basin associated with the WC
f. to be located on accessible routes that are direct and obstruction free
g. doors are preferably outward-opening and are fitted with a horizontal closing bar fixed to the inside face

> **Recommendations for current good practice**
> If the door opens inwards, the compartment should be enlarged and the door should be able to be opened outwards in an emergency

h. any wheelchair user should not have to travel:
 i) more than 40m on the same floor unless it can be argued that the circulation route is unobstructed, e.g. doors with hold open devices
 ii) more than a 40m combined horizontal distance where the unisex toilet is on another floor of the building but is accessible by passenger lift (if a lifting platform is installed, vertical travel to a unisex toilet to be limited to one storey)

> **Recommendations for current good practice**
> Note that management arrangements can ensure that disabled people can attend meetings, or work, in areas which are conveniently close to Accessible WCs

i. the minimum overall dimensions of, and the arrangement of fittings within, a wheelchair-accessible unisex toilet, to comply with Diagram 18

> **Recommendations for current good practice**
> Diagram 18 shows key dimensions on plan

j. where the horizontal support rail on the wall adjacent to the WC is set with the minimum spacing from the wall an additional drop-down rail to be provided on the wall side at a distance of 320mm from the centre line of the WC

Recommendations for current good practice
This is the normal arrangement but see 5.10k below

k. where the horizontal support rail on the wall adjacent to the WC is set so that its centre line is 400mm from the centre line of the WC, there is no additional drop-down rail

Recommendations for current good practice
A wall mounted grab rail set at a greater distance than normal from the wall can give greater support than a drop-down rail (ADM 5.8)

l. the heights and arrangement of fittings in a wheelchair accessible unisex toilet to comply with Diagram 19 and, as appropriate, Diagram 20

Recommendations for current good practice
Diagrams 19 and 20 show key dimensions in elevation

m. an emergency assistance alarm system to be provided, complying with 5.4
n. the emergency assistance call signal outside the toilet compartment to be located so that it can be easily seen and heard by those able to give assistance
o. an emergency assistance pull cord to be easily identifiable (see 4.30e) and reachable from the WC and from the floor close to the WC
p. any heat emitters to be located so that they do not restrict the minimum clear wheelchair manoeuvring space, nor the space beside the WC used for transfer from the wheelchair to the WC
q. WC pans to confirm to BS 5503-3 or BS 5504-4 in terms of key dimensions in order to accommodate the use of a variable toilet set riser (see 5.9)
r. cisterns for WCs that will be used by wheelchair users to have their flushing mechanism on the open or transfer side to the space, irrespective of handing

Recommendations for current good practice
Flushing handles are commonly, and incorrectly, fitted on the right-hand side of the pan even when this is not the open or transfer side

Toilets in separate-sex washrooms

ADM: 5.11–13

Design considerations
Benefits for ambulant disabled people of suitable separate sex toilet accommodation and of larger cubicles for people who need extra space

Recommendations for current good practice
BS 8300/12.4.3

ADM: 5.14

Provisions (unless otherwise justified in an Access Statement):

a. the swing of any inward opening doors to standard WC compartments to be such that a 450mm diameter manoeuvring space is maintained between the swing of the door, the WC pan and the side wall of the compartment

> **Recommendations for current good practice**
> This space assists most people when entering or leaving the WC

b. the minimum dimensions of the compartments for ambulant disabled people, including the activity space, and the arrangement of grab bars and other fittings within the compartment, to comply with Diagram 21

> **Recommendations for current good practice**
> Diagram 21 shows a cubicle width of 800mm

c. doors to compartments for ambulant disabled people to be preferably outward-opening and to be fitted with a horizontal closing bar fixed to the inside face

> **Recommendations for current good practice**
> Other fittings for closing doors may be considered, e.g. a towel rail on the door

d. an enlarged compartment for those who need extra space (based on the compartment for ambulant disabled people) to be 1200mm wide and include a horizontal grab bar adjacent to the WC, a vertical grab bar on the rear wall and a space for a shelf and fold-down changing table

> **Recommendations for current good practice**
> Useful for people with luggage etc.; this is more likely to apply to public buildings than to offices and similar premises

e. any compartment for use by ambulant disabled people to have a WC pan to conform to BS 5503-3 or BS 5504-4 in order to accommodate the use of a variable toilet set riser (see 5.9 and 5.11)

f. a wheelchair-accessible compartment (where provided) to have the same layout and fittings as the unisex toilet

g. any wheelchair-accessible washroom to have a least one washbasin with its rim set at 720–740mm above the floor and, for men, at least one urinal with its rim set at 380mm above the floor, with two 600mm long vertical grab bars with their centre lines at 1100mm above the floor, positioned either side of the urinal

Wheelchair-accessible changing and shower facilities

ADM: 5.15–17

Design considerations
Choice of layout; detailed considerations for changing and shower facilities

> **Recommendations for current good practice**
> BS 8300/12.3

ADM: 5.18

Provisions (unless otherwise justified in an Access Statement):

For changing and shower facilities

a. a choice of layouts to be suitable for left-hand and right-hand transfer to be provided when more than one individual changing compartment or shower compartment is available

b. to be provided with wall mounted drop-down support rails and wall mounted slip-resistant tip-up seats (not spring-loaded)

c. in communal shower facilities and changing facilities to be provided with subdivisions that have the same configuration of space and equipment as for self-contained facilities but without doors

d. in sports facilities, individual self-contained shower facilities and changing facilities to be available in addition to communal separate-sex facilities

e. an emergency assistance pull cord complying with 4.30e to be easily identifiable and reachable from the wall mounted tip-up seat, or from the floor

f. an emergency assistance alarm to comply with 5.4h

g. facilities for limb storage to be included for the benefit of amputees

For changing facilities

h. the minimum overall dimensions of, and the arrangement of equipment and control within, individual self-contained changing facilities to comply with Diagram 22

i. when associated with shower facilities, the floor of a changing area to be level and slip resistant when dry or wet

j. a manoeuvring space 1500mm deep in front of lockers in self-contained or communal changing areas

For shower facilities

k. individual self-contained shower facilities to comply with Diagram 23

l. where showers are provided in commercial developments for the benefit of staff, at least one wheelchair-accessible shower compartment to comply with Diagram 23

m. a shower curtain, which encloses the seat and the rails when they are in a horizontal position, able to be operated from the shower seat

n. a shelf that can be reached from the shower seat or from the wheelchair, before or after transfer, to be provided for toiletries

o. the floor of the shower and shower area to be slip resistant and self-draining

p. a shower terminal fitting to comply with the Water Supply Regulations 1999 and the markings on the shower control to be logical and clear

q. where wheelchair-accessible shower facilities are available in communal areas, shower controls to be positioned at 750–1000mm above the floor

r. the minimum overall dimensions of, and the arrangement of fittings within, an individual self-contained shower area incorporating a corner WC, e.g. in a sports building, to comply with Diagram 24

s. a choice of left-hand and right-hand transfer layouts to be available when more than one shower area is provided

Wheelchair-accessible bathrooms

ADM: 5.19–20 **Design considerations**
Choice of layout; detailed considerations for accessible bathrooms

> **Recommendations for current good practice**
> BS 8300/12.2

ADM: 5.21 **Provisions (unless otherwise justified in an Access Statement):**
a. the minimum overall dimensions of, and the arrangement of fittings within, a bathroom for individual use incorporating a corner WC to comply with Diagrams 25 and 26
b. a choice of layouts suitable for left-hand and right-hand transfer to be provided when more than one bathroom for individual use incorporating a corner WC is available
c. the floor of a bathroom to be slip resistant when dry or wet
d. the bath to be provided with a transfer seat, 400mm deep and equal to the width of the bath
e. doors to be preferably outward-opening and fitted with a horizontal closing bar fixed on the inside face
f. an emergency assistance pull-cord complying with 4.30e to be easily identifiable and reachable from the bath or from the floor
g. an emergency assistance alarm to comply with 5.4h

Means of access to and into dwellings

References: Lifetime Homes (LTH), Standards 1–6

ADM: 6.1–3 **Objectives**
To make reasonable provision within the boundary of the plot of the dwelling for a disabled person to approach and gain access into the dwelling from the point of alighting from a vehicle, which may be within or outside the plot. In most circumstances it should be possible to provide a level or ramped approach

Approach to the dwelling

ADM: 6.4–10 **Design considerations**
Appproach to be safe and convenient for disabled people, ideally level or ramped, but steps may be unavoidable; location of car parking space may assist; surface of routes to be firm and smooth with widths suitable for wheelchair users etc.

ADM: 6.11 **Provisions (unless otherwise justified in an Access Statement):**
Within the plot of the dwelling, a suitable approach to be provided from the point of access to the entrance. The point of access should be reasonably level and the approach should not have crossfalls greater than 1 in 40

> **Recommendations for current good practice**
> See LTH Standard 1

ADM: 6.12 The whole, or part, of the approach may be a driveway

> **Recommendations for current good practice**
> See LTH Standard 2

ADM: 6.13 *Level approach*
A "level" approach to have a gradient of not more than 1 in 20, its surface to be firm and even and its width not less than 900mm

> **Recommendations for current good practice**
> See LTH Standard 3

ADM: 6.14 *Ramped approach*
If the topography is such that the route from the point of access towards the entrance has a plot gradient exceeding 1 in 20 but not exceeding 1 in 15, a ramped approach may be provided

ADM: 6.15 *A ramped approach to have:*
a. a surface which is firm and even
b. flights whose unobstructed widths are at least 900mm
c. individual flights not longer than 10m for gradients not steeper than 1 in 15, or 5m for gradients not steeper than 1 in 12

> **Recommendations for current good practice**
> Note that the permitted length of ramps at 1 in 15 and 1 in 12 is greater for dwellings than for other building types (see 1.26 and 3.53a)

d. top and bottom landings and, if necessary, intermediate landings, each of whose lengths is not less than 1.2m, exclusive of the swing of any door or gate which opens onto it

ADM: 6.16 *Stepped approach*
If the topography is such that the route (see ADM 6.6–6.8) from the point of access to the entrance has a plot gradient exceeding 1 in 15, a stepped approach may be provided

> **Recommendations for current good practice**
> Note that only for dwellings is a stepped approach ever acceptable under ADM

ADM: 6.17 *A stepped approach to have:*
a. flights whose unobstructed widths are at least 900mm
b. the rise of a flight to be not more than 1.8m
c. top and bottom landings and, if necessary, intermediate landings, each of whose lengths is not less than 900mm
d. steps with suitable tread and nosing profiles (see Diagram 27) and the rise of each step is uniform and between 75mm and 150mm

> **Recommendations for current good practice**
> Note: the dimensions for steps on the approach to dwellings is different from those for other building types (see 1.33h)

e. the going of each step to be not less than 280mm, which for tapered treads should be measured at a point 270mm from the "inside" of the tread

f. where the flight comprises three or more risers, there is a suitable continuous handrail on one side of the flight. A suitable handrail should have a grippable profile; be 850–1000mm above the pitch line of the flight; extend 300mm beyond the top and bottom nosings

ADM: 6.18

Approach using a driveway

Where a driveway provides a means of approach towards the entrance, to have an approach past any parked cars in accordance with ADM 6.11–6.27

Access into the dwelling

ADM: 6.19–20

Design considerations

Where the approach consists of a level or ramped approach, an accessible threshold to be provided; where the approach is stepped it would still be reasonable to provide an accessible threshold; if a step into the dwelling is unavoidable, the rise should be not more than 150mm

ADM: 6.21

If the approach to the dwelling or block of flats consists of a level or ramped approach, an accessible threshold to be provided

Recommendations for current good practice

See LTH Standard 4

Entrance doors

ADM: 6.22

Design considerations

Door opening widths to be suitable for a wheelchair user

ADM: 6.23

Provisions (unless otherwise justified in an Access Statement):

An external door providing access for disabled people to have a minimum clear opening width of 775mm

Recommendations for current good practice

Note: for dwellings, the clear opening width is taken from the face of the door stop on the latch side to the face of the door when open at 90 degrees. This differs from the clear opening width for other building types, in which the opening is taken to be clear of door furniture. The explanation is that in most buildings the door furniture, such as a vertical handrail, may extend to the lower part of the door and reduce that space for a wheelchair to pass, whereas for dwellings the door furniture is unlikely to extend below the level of the latch. (See ADM 3.10b for door widths in buildings other than dwellings)

See LTH Standard 6

Circulation within the entrance storey of the dwelling

References: Lifetime Homes (LTH), Standard 12

ADM: 7.1

Objectives
To facilitate access within the entrance storey or the principal storey of the dwelling, into habitable rooms and a room containing a WC, which may be a bathroom on that level

Corridors, passageways and internal doors within the entrance storey

ADM: 7.2–4

Design considerations
Width to be suitable for wheelchair users, with minimum obstructions; also applies to internal doors

ADM: 7.5

Provisions (unless otherwise justified in an Access Statement):
a. a corridor, or other access route in the entrance storey or principal storey serving habitable rooms and a room containing a WC (which may be in a bathroom) on that level, to have an unobstructed width in accordance with Table 4
b. a short length (no more than 2m) of local permanent obstruction in a corridor, such as a radiator, would be acceptable provided that the unobstructed width of the corridor is not less than 750mm for that length, and the local permanent obstruction is not placed opposite a door to a room if it would prevent a wheelchair user turning into or out of the room
c. doors to habitable rooms and a room containing a WC to have minimum clear opening widths as shown in Table 4, when accessed by corridors or passageways whose widths are in accordance with those listed in Table 4

> **Recommendations for current good practice**
> See LTH Standard 6

Vertical circulation within the entrance storey

ADM: 7.6

Design considerations
If a change of level is unavoidable, stair to include handrails at both sides

> **Recommendations for current good practice**
> See LTH Standard 12

ADM: 7.7

Provisions (unless otherwise justified in an Access Statement):
A stair providing vertical access within the entrance storey of the dwelling to have:
a. flights whose clear widths are at least 900mm
b. a suitable continuous handrail on each side of the flight and any intermediate landings where the rise of the flight comprises three or more risers
c. the rise and going are in accordance with the guidance in Approved Document K for private stairs

Accessible switches and socket outlets

References: Lifetime Homes (LTH), Standard 16

ADM: 8.1

Objectives
To assist those people whose reach is limited to use the dwelling more easily by locating wall-mounted switches and socket outlets at suitable heights

ADM: 8.2

Design considerations
Located to be easily reached

> **Recommendations for current good practice**
> See LTH Standard 16

ADM: 8.3

Provisions (unless otherwise justified in an Access Statement):
A way of satisfying Requirement M1 would be to provide switches and socket outlets for lighting and other equipment in habitable rooms at appropriate heights between 450mm and 1200mm from finished floor level (see Diagram 29)

Passenger lifts and common stairs in blocks of flats

References: Lifetime Homes (LTH), Standard 5

ADM: 9.1–2

Objectives
For buildings containing flats, the objective should be to make reasonable provision for disabled people to visit occupants who live on any storey

ADM: 9.3–4

Design considerations
If there is no lift between storeys, a stair to be provided to suit the needs of ambulant disabled people and people with impaired sight; a lift, if provided, to be suitable for an unaccompanied wheelchair user and for a person with sensory impairments

Common stairs

> **Recommendations for current good practice**
> See LTH Standard 5a

ADM: 9.5

Provisions (unless otherwise justified in an Access Statement):
a. all step nosings to be distinguishable through contrasting brightness
b. top and bottom landings to have lengths in accordance with Part K1
c. steps to have suitable tread and nosing profiles (see Diagram 30) and uniform rise of each step to be not more than 170mm
d. uniform going of each step to be not less than 250mm, which for tapered treads should be measured at a point of 270mm from the inside of the tread
e. risers which are not open
f. a suitable continuous handrail on each side of the flights and landings if the rise of the stair comprises two or more risers

Lifts

> **Recommendations for current good practice**
> See LTH Standard 5b

ADM: 9.6 A building, or part of a building which contains flats above the entrance storey, and in which passenger lift access is to be installed, to have a suitable passenger lift with a maximum load capacity of 400kg

> **Recommendations for current good practice**
> None of this implies that blocks of flats may not be constructed with staircase access only, without a lift

ADM: 9.7 One way of satisfying Requirement M1 would be to provide a passenger lift which has:
a. a clear landing of at least 1500mm long in front of its entrance
b. a door or doors which provide a clear opening width of at least 800mm
c. a car whose width is at least 900mm and whose length is at least 1250mm

> **Recommendations for current good practice**
> Note that this is smaller than the minimum size of 1100 × 1400mm for passenger lifts in non-residential buildings (see ADM 3.34 c) and allows for a wheelchair user alone, without a companion

d. landing and car controls which are not less than 900mm and not more than 1200mm above the landing and the car floor, at a distance of at least 400mm from the front wall
e. accompanied by suitable tactile indication on the landing and adjacent to the lift call button to identify the storey in question

> **Recommendations for current good practice**
> See ADM 3.28c

f. suitable tactile indication on or adjacent to lift buttons within the car to confirm the floor selected
g. incorporate a signalling system which gives visual notification that the lift is answering a landing call and a "dwell time" of 5 seconds before its doors begin to close after they are fully open: the system may be overridden by a door re-activation device which relies on appropriate electronic methods, but not a door edge pressure system, provided that the minimum time for a lift door to remain fully open is 3 seconds
h. when the lift serves more than 3 storeys, to incorporate visual and audible indication of the floor reached

WC provision in the entrance storey of the dwelling

References: Lifetime Homes (LTH), Standards 7–11 and 13–15

WC provision in the entrance storey of the dwelling

ADM: 10.1

Objectives
To provide a WC in the entrance storey of the dwelling and to locate it so that there should be no need to negotiate a stair to reach it from the habitable rooms in that storey. Where the entrance storey contains no habitable rooms, it is reasonable to provide a WC in either the entrance storey or the principal storey

ADM: 10.2

Design considerations
Provide a WC within the entrance storey or principal storey of a dwelling; the WC may be in a bathroom; not always practical for the wheelchair to be fully accommodated within the WC compartment

Recommendations for current good practice
See LTH Standard 10

ADM: 10.3

Provisions (unless otherwise justified in an Access Statement):
a. a WC to be provided within the entrance storey or the principal storey of a dwelling which contains a habitable room; or where the dwelling is such that there is no habitable room in the entrance storey, if a WC is provided in either the entrance storey or the principal storey
b. the door to the WC compartment to open outwards, and be positioned to enable wheelchair users to access the WC and to have a clear opening width in accordance with Table 4 (door widths wider than the minimum in Table 4 allow easier manoeuvring and access to the WC by wheelchair users)
c. the WC compartment to provide a clear space for wheelchair users to access the WC (see Diagrams 31 and 32) and the washbasin to be positioned so that it does not impede access

Wheelchair accessibility

Recommendations for current good practice
See LTH Standard 7

Living room

Recommendations for current good practice
See LTH Standard 8

Bed space at entrance level

Recommendations for current good practice
See LTH Standard 9

Bathroom and WC walls

> **Recommendations for current good practice**
> See LTH Standard 10

Route from bedroom to bathroom

> **Recommendations for current good practice**
> See LTH Standard 13

Bathroom accessibility

> **Recommendations for current good practice**
> See LTH Standard 14

Living room windows etc.

> **Recommendations for current good practice**
> See LTH Standard 15

Lifetime Homes standards

Lifetime Homes standards were initiated by the Rowntree Trust in the early 1990s and these standards have since been developed by housing agencies, by the Greater London Authority and by other local authorities. For many local authorities the achievement of these standards is now a condition of planning approval for residential development but the interpretation of the standards varies. The following notes should therefore be treated as general guidance and the detailed requirements should be checked with the relevant local authority.

The Rowntree Trust describes Lifetime Homes as having sixteen design features that ensure a new house or flat will meet the needs of most households and emphasises that "The accent is on accessibility and design features that make the home flexible enough to meet whatever comes along in life: a teenager with a broken leg, a family member with serious illness, or parents carrying in heavy shopping and dealing with a pushchair."

LTH Standard 1

Where there is car parking adjacent to the home, it should be capable of enlargement to attain 3300mm width

Recommendations for current good practice

1. Where NO other parking is provided within a scheme, then parking spaces for disabled people are NOT a requirement to meet Lifetime Homes Standards
2. Part M (2004) does NOT include requirements for designated residential parking
3. A standard bay (2400mm) is too narrow to open doors wide, restricting access for disabled people. An adjoining 900mm path will provide additional bay width for easier access
4. Where parking is grouped, end bays are likely to have the advantage of an adjoining path for easier access
5. Parking spaces for disabled people are generally required for all units provided to Wheelchair Housing Standards
6. Where parking spaces are provided then inclusion of some short term parking for support services (e.g. nurses) is recommended

LTH Standard 2

The distance from the car parking space to the home should be kept to the minimum and should be level or gently sloping

Recommendations for current good practice

1. Where a designated parking space is assigned to a unit it should be as close as possible to the associated block entrance – within 50 metres if exposed to weather, 100 metres if under a covered approach
2. Where the building is a mixed use development and Part M requirements differ for non-residential and residential uses, then requirements for non domestic uses apply.
 "Level" approach for mixed developments includes the following critical requirements (see ADM 1.13):
 - 1500 surface width (1200mm on restricted sites) with1800mm passing places
 - Gradients between 1:20 and 1:60 with level landings provided for each 500mm rise
 - Separation of pedestrian and vehicular routes
 - Clear identification and good lighting
 - Ramp (ADM 1.26) and step (ADM 1.33) criteria also differ between dwellings and other building types

LTH Standard 3

The approach to all entrances should be level or gently sloping

Recommendations for current good practice

ADM 1.13 describes a "level approach" as having a gradient along its length no steeper than 1:60. In practice, a gradient of 1:40 can be considered to be almost identical to 1:60 and is often easier to achieve

LTH Standard 4

All entrances should be

a. illuminated
b. have level access over the threshold
c. have a covered main entrance

Recommendations for current good practice

1. Non residential Part M standards may apply if building is in mixed use (ADM 2.7)
 Critical features are:
 - Identifiable entrance
 - Level landing at least 1500mm sq. clear
 - Max threshold height 15mm
 - Weather protection at non-powered entrance doors
 - Internal floor surfaces and mats to be wheelchair accessible and not to create a trip hazard

2. Covered and illuminated entrances are recommended for shelter, safety and security

LTH Standard 5

Communal stairs should provide easy access

Where homes are reached by a lift, it should be fully accessible

Recommendations for current good practice

Ref. ADM section 9

LTH Standard 6

The width of the doorways and hallways should conform to the following specifications to enable wheelchair user access:

Doorway clear opening width (mm)	Corridor/passageway width (mm)
750 or wider	900 (when approach is head on)
750	1200 (when approach not head on)
775	1050 (when approach not head on)
800	900 (when approach not head on)

Doors to have a space 300mm wide adjacent to the leading edge of the door

Recommendations for current good practice

The requirement for a space 300mm wide adjacent to the leading edge of the door is often difficult to achieve in small dwellings. This may need to be considered at the planning stages of a project if space problems are not to be encountered at the stages of detailed design. The purpose of the 300mm space is to enable a wheelchair user to pull the door open, therefore there should be no need for a 300mm space on the push side of the door

LTH Standard 7
There should be space for turning a wheelchair in dining areas and living rooms and adequate circulation space for wheelchairs elsewhere

Recommendations for current good practice
This standard is generally not difficult to achieve (e.g. 1500mm turning circle)

LTH Standard 8
The living room should be at entrance level

LTH Standard 9
In houses of two or more storeys, there should be space on the entrance level that could be used as a convenient bed-space

LTH Standard 10
There should be:

a. a wheelchair accessible entrance level WC, with
b. drainage provision enabling a level access shower to be fitted in the future

For dwellings at one level, i.e. flats, the WC should be fully accessible with transfer space 750 × 750mm at the side and 1100mm clear in front of the pan

LTH Standard 11
Walls in bathrooms and WCs should be capable of taking adaptations such as handrails

LTH Standard 12
The design should incorporate:

a. provision for a stair lift
b. a suitably identified space for a through-the-floor lift from the ground to the first floor, for example to a bedroom next to a bathroom

LTH Standard 13
The design should provide a reasonable route for a potential hoist from a main bedroom to the bathroom

Recommendations for current good practice
Note that portable hoists may provide an alternative to fixed hoists with fixed routes

LTH Standard 14
The bathroom should be designed to incorporate ease of access to the bath, WC and washbasin

Recommendations for current good practice
1. Wall hung basins and WC pans will provide more floor space for wheelchair users to manoeuvre
2. Installing a level access shower outlet at the same time as a bath waste will allow for either option at a later date

3. Installing WC to side connecting 'P' traps as opposed to 'S' traps allows for future re-positioning
4. Combine horizontal door rail with towel rail
5. Positioning WC pan adjacent to bath allows user to transfer into bath more easily

LTH Standard 15
Living room window glazing should begin at 800mm or lower and windows should be easy to open/operate

1. Seated people including wheelchair users should be able to look out of a living room window
2. Wheelchair users should be able to open at least one window in a living room but safety of children must be considered
3. Window catches should be fitted no higher than 1200mm for easy operation

LTH Standard 16
Switches, sockets, ventilation and service controls should be at a height usable by all (i.e. between 450 and 1200mm from the floor)

Wheelchair Housing standards checklist

Wheelchair Housing standards are based on the "Wheelchair Housing Design Guide" (Habinteg, 2006). Many of the standards are similar to those of Lifetime Homes, with additional requirements to meet the needs of wheelchair users. The standards for external circulation spaces and ramps are similar to those recommended in Approved Document Part M (ADM) for buildings other than dwellings, which are more onerous than those for dwellings.

Interpretation of Wheelchair Housing standards varies with different local authorities and the requirements should be checked with the relevant local authority.

As a general guide, a dwelling designed to Wheelchair Housing standards should be designed as for Lifetime Homes with the following additional features:

1. *Moving around outside*
 - As for ADM for non-dwellings and LTH standards

2. *Using outdoor spaces*
 - Gates with clear opening 850mm, operated from either side

3. *Approaching the home*
 - Covered parking space for each ground floor wheelchair user's dwelling
 - Level landing 1500 × 1500mm plus 1200mm depth clear of any door opening
 - Canopy 1200mm deep × 1500mm wide

- Where wheelchair dwellings are above ground floor, lift to be as ADM (1100 × 1400mm)
- A second lift to be available for use when first lift is not operational

4. *Negotiating the entrance door*
 - Space beside leading edge of door: 200mm on push side; 300mm on pull side, extending 1800mm from face of door

5. *Entering and leaving; dealing with callers*
 - Transfer space to transfer to, or store, a second wheelchair
 - Turning space 1800 × 1500mm behind door plus 300mm space beside leading edge of door

6. *Negotiating a secondary external door (to garden etc.)*
 - Level landing 1500 × 1500mm, with 1200mm clear of door opening

7. *Moving around inside*
 - Corridor width 900mm clear with space at leading edge 200mm on push and 300mm on pull side
 - Corridor widths for turning 1200mm for 90° turn, 1500mm for 180° turn
 - Effective clear widths for doors 775mm

8. *Moving between levels within the dwelling*
 - Provide space for a future lift, plus space to manoeuvre, call lift, open door and use lift

9. *Using living spaces*
 - Circulation spaces generally 1000mm, but 1350mm for opening drawers

10. *Using the kitchen*
 - Circulation space 1800 × 1500mm

11. *Using the bathroom*
 - Bathroom to be fully accessible with 1500 × 1500mm square manoeuvring space and level access shower (1000 × 1000mm), with provision for a bath in place of a shower

12. *Using bedrooms*
 - 1000mm transfer space on both sides of a double bed and on one side of a single bed
 - 1200 × 1200mm square activity space

13. *Operating internal doors*
 - Allow for possible future fitting of large pull handles etc.

14. *Operating windows*
 - As LTH

15. *Controlling services*
 - As LTH

6. Stages FGHJK: Production Information, Tender Documentation and Action, Mobilisation and Construction to Practical Completion

Procuring accessibility

The guidance published by DPTAC and supported by CABE recommends that at the stages of production information, tender action and at the pre-contract stages of a project particular attention is given to the following:

- ensure inclusive design details are incorporated into the contract documentation for the buildings, fixtures and fittings
- appraise any novated design in response to access procurement.

Planning the construction process

Construction workers on site may not understand the reasons for design details which are intended to make buildings easier for disabled people to use and frequently carry out work which varies slightly but significantly from the design proposals. A typical example is that plumbers commonly fit the flushing lever on the right hand side of an accessible WC, even if the design drawings show the transfer space and the flushing lever on the left hand side.

The numerous features which can result in unintended physical obstacle for disabled people include:

• external routes	bollards, lamp posts or columns located inaccurately; surface finishes which are uneven or have trip hazards
• entrances	unplanned changes of level or ramps
• internal routes	restrictions of corridor widths by service ducts which are larger than originally anticipated
• doors	problems of access space in front of doors; door controls out of reach for wheelchair users; doors hung incorrectly or with fittings which are not as specified
• sanitation	WC locks difficult to use; colour contrasts inadequate (e.g. white on white)
• handrails	fixings which impeded finger grips; inadequate extension at top or bottom of steps or ramps
• internal finishes	lack of colour contrasts; shiny surfaces causing glare
• lighting	illumination which causes glare or confusing reflections

The detailed Access Statement which should have been submitted with the application for Building Regulations approval, and possibly developed with further details with guidance for contractors, can provide a check to ensure that the contractual arrangements to achieve accessibility in the completed building have been made.

Because it is essential to monitor progress on site in order to ensure that the proposals for inclusive design are implemented correctly, and to identify any errors sufficiently early for these to be rectified, site supervision should preferably be planned to include inspections by an access consultant or someone with sufficient understanding of the reasons for the detailed design, including the considerations for disabled people.

7. Stage L: Post Practical Completion

As noted in the previous section, it is important that the construction details are monitored on site to check that the design proposals to achieve accessibility are carried out as intended. When a building project has been completed, handed over and occupied, a number of different considerations need to be fulfilled if the premises are to be inclusive and suitable for all users, including disabled people, and if the objectives of the DDA are to be achieved. These include:

1. The physical premises:
 • easy to find, to enter, to access the internal spaces and with facilities which are convenient to use
 • wayfinding, information and communications suitable for everyone
 • the minimum standards are as Approved Document Part M but the suitability and convenience of the premises can be greatly increased for many people if the design has followed the recommendations of BS 8300 and other guidelines to good practice
2. The managed environment:
 • practices, policies and procedures to promote access for all
 • staff training, resulting in awareness of possible needs and the ability to provide assistance
 • landlords and controllers of premises enabled to meet their obligations under the DDA
 • emergency escape plans, particularly managed escape for disabled people
3. Adjustments to meet the needs of disabled members of staff (under DDA Part 3). The ability to respond to the needs of individuals can be greatly facilitated if adaptable services and facilities have been pre-planned, e.g.
 • clear circulation routes without hazards
 • electric sockets and computer connections at suitable heights
 • lighting installations which are adaptable at individual workstations

If the objectives of the legislation have been achieved, the completed premises should be inclusive, safe and convenient for everyone to use. Although a building cannot "comply with the DDA", the designers of the completed premises should be able to demonstrate that the design meets the recommendations of current good practice for access and usability and that this will enable the managers and occupiers of the premises to comply with their obligations under the DDA.

8. Inclusive Design Policy

Reference: This draft is based on current good practice, with particular reference to "Planning and Access for Disabled People: A Good Practice Guide" (ODPM, 2003). The draft is adapted from material prepared with David Bonnett Associates.

A statement of an inclusive design policy may be required by a local authority to ensure a long term commitment to inclusivity by the developer of occupants of the premises. The following note outlines an example of an inclusive design policy.

An inclusive design policy should aim to promote inclusive design in all property development and management projects. This policy recognises that an inclusive environment can be used by everyone, regardless of age, gender or disability. It is made up of many elements such as society's and individuals' attitudes, the design of products and communications and the design of the built environment itself. The policy also recognises the benefits of an inclusive society, where everyone can benefit from intelligent, logical and accessible design and participate fully as equal citizens.

The policy requires inclusive design to form part of all concept briefs to architects or other designers, including to:

- Take professional advice from appropriately qualified access professionals on the preparation of design briefs and access statements.
- Ensure that architects and designers have appropriate expertise, or professional advice from an independent access consultant.
- Ensure at concept stage that the project team understands the fundamentals of inclusive access, with reference to the location of the building, site gradients, the relationships to adjoining buildings, the transport infrastructure and the design of the building.
- Liaise with the relevant statutory authorities as early as possible.
- Keep suitable professionals involved throughout the design and construction process.
- Consider how the completed building will be occupied and managed in order to minimise barriers to access at that stage.

The inclusive design policy recognises the need to work closely with local authorities to facilitate their role in the process of planning and building control, including the following where appropriate:

- Pre-application consultations
- Conditions attached to a planning permission to assist in the delivery of inclusive environments
- Legal agreements, including those under Section 106, to secure inclusive environments
- Access statements to identify:
 - the philosophy and approach to inclusive design

- the key issues of the particular scheme
- the sources of advice and guidance used.
- Access Officers' role in connection with:
 - the development of access policies and design guidance
 - technical consultation with other agencies including English Heritage, CABE, Building Control and the Statutory Highway Authority
 - liaison with other authorities
 - assistance to local access groups, including arranging for these to assist in the assessment of planning applications and raising awareness of access issues
 - staff training and CPD.
- Building control – the policy recognises that:
 - the inclusive design strategy involves a continuous process starting with the initial design brief or master plan, through the planning process to the detailed design stage and building control approval
 - the inclusive design strategy safeguards the applicant in the areas between building and civil rights legislation, including the DDA 1995
 - Part M of the Building Regulations requires that there should be reasonable provisions for access to and use of buildings by disabled people, but this deals only with the minimum standards of design and cannot deliver a fully inclusive environment
 - good practices in inclusive design are likely to vary from the minimum standards of Approved Document Part M and may involve creative design solutions
 - building regulation consent is to be determined via an application to the local authority's building control department, or by the use of an approved inspector, with the objective of achieving the standards of current good practice for accessibility.
- A policy to promote inclusive environments requires appropriate action at the occupancy and management stages of a project including:
 - staff training
 - information and signage
 - cleaning and maintenance
 - emergency escape and evacuation plans.

9. Building Regulations: Part M Schedule

This schedule relates specifically to Sections M1–M10 of the Building Regulations Part M 2004. If used to support an Access Statement submitted with an application for Building Regulations approval, this schedule has the merit of setting out the access issues in the order in which they are likely to be checked to ensure compliance with Approved Document Part M.

Part M Section 1

Section 1	Item ref	Location	Comments
Level external approach Section 1.1–1.12	Provision 1.13 (a–h)		
Parking and setting down Section 1.14–1.17	Provision 1.18 (a–e)		
Ramped external access Section 1.19–1.25	Provision 1.26 (a–n)		
Stepped access Section 1.27–1.32	Provision 1.33 (a–p)		
	1.33g		
Handrails Section 1.34–1.36	Provision 1.37 (a–l)		
Hazards Section 1.38	Provision 1.39 (a–b)		

Part M Section 2

Section 2	Item ref	Location	Comment
Accessible entrances Section 2.1–2.6	Provision 2.7 (a–j)		
Accessible entrances Section 2.8–2.12	Provision 2.13 (g–c)		
Manual doors Section 2.14–2.16	Provision 2.17 (a–d)		
Powered doors Section 2.18–2.20	Provision 2.21 (a–g)		
Glass entrance doors and screens Section 2.22–2.23	2.22		
	Provision 2.24 (a–d)		
Entrance lobbies Section 2.25–2.28	Provision 2.29 (a–h)		

Part M Section 3

Section 3	Item ref	Location	Comment
Signage and information	Provision 3.5 note		
Reception 3.1–3.5	Provision 3.6 (a–g)		
Internal doors 3.7–3.9	Provision 3.10 (a–j)		
Corridors and passageways 3.11–3.13	Provision 3.14 (a–l)		
Internal lobbies 3.15	Provision 3.16 (a–f)		
Production room 2.208			
Passenger lifts 3.17–3.23	Provision 3.24 (a–d)		
General lift design 3.25–3.27	Provision 3.28 (a–g)		
Lifts car design 3.29–3.33	Provision 3.34 (a–k)		
Evacuation lifts	Provision 3.34 (l)		
Lifting platforms 3.35–3.42	Provision 3.43 (a–m)		
Wheelchair platform stairlifts 3.44–3.48	Provision 3.49 (a–h)		
Internal stairs 3.50	Provision 3.51 (a–e)		
Internal ramps 3.52	Provision 3.53 (a–e)		
Handrails to steps and ramps 3.54	Provision 3.55		

Part M Section 4

Section 4	Item ref	Location	Comment
Audience/ spectator seating 4.1–4.11	Provision 4.12 (a–m)		
Refreshment facilities 4.13–4.15	Provision 4.16 (a–d)		

Section 4	Item ref	Location	Comments
Sleeping accommodation 4.17–4.23	Provision 4.24 (a–r)		
Switches outlets and controls 4.25–4.29	Provision 4.30 (a–m)		
Aids to communications 4.31–4.35	Provision 4.36 (a–f)		

Part M Section 5

Section 5	Item ref	Location	Comment
Sanitary accommodation 5.1–5.3	Provision 5.4 (a–k)		
WC cubicles for ambulant disabled people 5.5–5.6	Provision 5.7 (a–d)		
Wheelchair accessible unisex WCs (AWCs) for public and staff 5.8–5.9	5.10 (a–r)		
Travel distances	5.10 (hi–hii)		
Toilets in separate-sex washrooms 5.11–5.13			
Shower facilities 5.15–5.17	Provision 5.18 (a–s)		
Wheelchair-accessible bathrooms 5.19–5.20	Provision 5.12 (a–g)		
Emergency escape			

Dwellings

Section 6	Item ref	Location	Comment
Means of access to and into the dwelling 6.1–3			
Approach to the dwelling (6.4–6.10)	Provisions 6.11–12		
Level approach	Provisions 6.13		
Ramped approach	Provisions 6.14 6.15 (a–d)		
Stepped approach	Provisions 6.16 6.17 (a–f)		
Approach using a driveway	Provisions 6.18		
Access into the dwelling 6.19–6.21			
Entrance doors 6.22	Provisions 6.23		

Section 7	Item ref	Location	Comment
Circulation within the entrance storey of the dwelling 7.1			
Corridor, passageways and internal doors within the entrance storey 7.1–7.4	Provisions 7.5 (a–c)		
Vertical circulation within the entrance storey 7.6	Provisions 7.7		

Section 8	Item ref	Location	Comment
Accessible switches and socket outlets in the dwelling 8.1–8.2	Provisions 8.3		

Section 9	Item ref	Location	Comment
Passenger lifts and common stairs in blocks of flats 9.1–9.4	Provisions 9.5 (a–h)		

Section 10	Item ref	Location	Comment
WC provision in the entrance storey of the dwelling 10.1–10.2	Provisions 10.3 (a–c)		

10. RIBA Access and Inclusion Policy

Policy Principle/Access Statement

The RIBA is committed to the principles of inclusive design and inclusion in all aspects. The RIBA expects its members to embed "access for all" in their activities as designers and businesses.

Introduction

Inclusive design:

- places people at the heart of the design process
- acknowledges human diversity and difference
- offers choice where a single design solution cannot accommodate all users
- provides for flexibility in use
- aims to provide buildings and environments that are convenient, equitable and enjoyable to use by everyone, regardless of ability, age and gender

Centre for Accessible Environments (CAE), 2004.

Inclusion and access issues are certainly not confined to people with a disability, although the Disability Discrimination Act (DDA) has brought their needs to the fore. The spirit of this policy extends much further than roles and responsibilities for the institute as a service provider and educator, or for members as designers of the built environment. However, architects and other building professionals are seen to have a poor understanding of, or be slow to respond to, recent disability access legislation, therefore initial policy recommendations will concentrate on these issues. Policy recommendations will develop over time to encompass a wider remit as necessary.

As designers we need to have a thorough understanding of what causes barriers to access and focus on creating "access for all" in every environment we advise on or control, over and above meeting the basic requirements of building regulations.

It is important to consider disabled people in the same way we do others, not as a homogeneous group about which we can make sweeping generalisations, but as individuals with a complex mixture of needs, wants, talents and aspirations. The DDA defines disability as an "... impairment that has a substantial and long-term adverse effect on ... ability to carry out day-to-day activities". This affects over 11.7 million adults in the UK, including people with physical, sensory, or cognitive impairments and mental health issues. 25% of UK households have a disabled member and 2% of UK households have a member who is a wheelchair user. In a broader sense, it is estimated that 82% of the population is inconvenienced by the restrictions imposed by a poorly designed and managed environment. People are disabled by their environment and equally can be enabled by good design.

An inclusive approach to design offers new insights into how people interact with the built environment and new opportunities to deploy our creative and problem solving skills. Meeting access needs should not have a checklist approach but be an integral part of what we do every day, using our creativity and lateral thinking to find innovative and individual solutions, designing for real people in all their variability.

To achieve this policy the RIBA is committed to the following:

1. Supporting member's awareness of the needs of disabled people and their roles and responsibilities resulting from the DDA legislation.

Role of the RIBA	The practice/employer	The member/employee:
Increase and expand relevant CPD courses across the regions	Ensure that all staff members are fully trained in and aware of access issues	Make access training part of your annual cpd goals
Ensure specialist advice is available via the member's information line	Make staff aware of sources of information	Seek guidance from the member's information line when you are unsure of appropriate responses to access issues
Provide an area on the RIBA website dedicated to access and inclusion and providing links to useful documents and organisations	Make staff aware of sources of information	Seek advice on the RIBA's website and linked sites when you are unsure of appropriate responses to access issues
Include access and inclusion issues in the criteria for RIBA accredited undergraduate and postgraduate courses. Courses should embed inclusion issues into student projects and judging criteria	Review the practice design process and review system. Implement a mechanism to ensure that inclusion is integral to design decisions (see Appendix B)	Embed "access for all" into your design approach and philosophy
RIBA awards should promote understanding of the intentions of the RIBA Inclusive Design Award	Develop understanding of inclusive design and submit projects for assessment with an access statement	Suggest suitable projects to your practice
RIBA Enterprises should review and improve publications and other design tools related to inclusive design (* see Appendix A)	Provide publications and other design tools related to inclusive design to employees	Use publications and other tools related to inclusive design provided by your practice or available elsewhere
Involve disabled people in activities and consultation processes	Pro-actively engage disabled people in consultation processes	Improve your awareness of the needs of disabled people from consultation processes

2. Supporting best practice and setting the standard.

Role of the RIBA	The practice/employer	The employee
RIBA awards should embed inclusion into judging criteria	Submit projects for assessment with an access statement	Suggest suitable projects to your practice
Publish case study articles in the RIBA Journal	Submit suitable case studies to the RIBA Journal	Suggest suitable case studies to your practice
Hold exhibitions focused on good inclusive design	Submit projects for exhibition	Suggest suitable projects to your practice
Develop and publish a Model Policy for practices (** see Appendix A)	Adopt a policy and ethos statement for inclusion as part of office policies and practice	Familiarise yourself with office policy or suggest your employer adopt one
RIBA as an employer must ensure that operational practices and procedures including employment and staff training meet DDA and best practice standards wherever possible	Review their current office practices and procedures in relation to the DDA and implement accordingly (see Appendix B for Model Project Access Method Statement)	Familiarise yourself with office practice and procedures and suggest any improvements or solutions
RIBA as a service provider must ensure that access audit recommendations of all RIBA premises, including Portland Place, are incorporated into an access strategy to be implemented, monitored and reviewed regularly	Review their premises and make reasonable adjustments as required	Suggest any improvements or solutions to your employer as appropriate
RIBA as a service provider must ensure that all of the services provided and information supplied meets best practice e.g. training, exhibitions, website and all other communication mechanisms	Review and identify services provided and ensure reasonable adjustments are made to meet best practice e.g. company website	Suggest any improvements or solutions to your employer as appropriate

3. Maintaining and improving member's skills and policy actions.

Role of the RIBA	The practice/employer	The employee
Set up an access and inclusion taskforce to carry out, monitor and update the policy objectives	Allow employees time to participate in access groups – at the RIBA or local authority level	Volunteer and share information
Ensure RIBA representation on or dialogue with relevant groups such as CABE, DPTAC, CAE, NRAC etc.	Allow employees time to participate in disability action groups	Volunteer and share information
Encourage architects to develop access skills	Use access consultants where appropriate or consider training a member of staff to take this role	Improve your own access skills, consider training as an access consultant or suggest when one might be appropriate to your project's needs

11. References: DDA and Inclusive Design

Legislation

Disability Discrimination Act 1995
Special Education Needs and Disability Act (SENDA) 2001

Disability Rights Commission

Codes of practice:

- Disability Discrimination Act 1995 – duty to promote disability equality (England and Wales) 2005
- Rights of access to goods, facilities, services and premises (DDA Part 3)
- Transport: provision and use of transport vehicles (DDA Part 3)
- Education: Schools (DDA Part 4)
- Education: Post 16 – for providers of Post 16 education and related services (DDA Part 4)
- Provision and use of transport vehicles – code of practice, 2005

Building Regulations

Building Regulations 2000
 Approved Documents
 - Part B Fire safety, 2006
 - Part K Protection from falling, collision and impact, 2000
 - Part M Access to and use of buildings, 2004
 - Part N Glazing – safety in relation to impact, opening and cleaning, 2000

British Standards

BS 8300: 2001 Design of buildings and their approaches to meet the needs of disabled people. Amended October 2005

BS 5588 series: Fire precautions in the design, construction and use of buildings
 Part 0: 1996 Guide to fire safety codes of practice for particular premises/ applications
 Part 1: 1990 Code of practice for residential buildings
 Part 5: 1991 Fire-fighting stairs and lifts
 Part 8: 1999 Means of escape for disabled people
 Part 12: 2004 Evacuation of disabled people

BS 7000 series: Design management systems
 Part 1: 1999 Guide to managing innovation
 Part 4: 1994 Guide to managing design in construction
 Part 6: 2005 Guide to managing inclusive design

BS EN 81-70: 2003	Safety rules for the construction and installation of lifts, and accessibility to lifts including for disabled people
BS EN 81-71: 2005	Safety rules for the construction and installation of lifts
BS 6440: 1999	Powered lifting platforms for use by disabled people
BS 7997: 2003	Products for tactile paving surface indicators

ODPM

Planning and access for disabled people – a good practice guide, 2003

Department of Environment, Transport and the Regions (DETR)

Guidance on the use of tactile paving surfaces, 1998

Department of Transport (DoT)

Inclusive mobility – a guide to best practice on access to pedestrian and transport infrastructure, 2002

Department of Transport, Local Government, Regions (DTLR)

The Rail Vehicle Accessibility Regulations, 2002

Strategic Rail Authority (SRA)

Train and station services for disabled people – code of practice, 2002

Disabled Persons Transport Advisory Committee (DPTAC)

Inclusive Projects – a guide to best practice on preparing and delivering project briefs to secure access, 2003

English Heritage

Easy access to historic buildings, 2004
Easy access to historic landscapes, 2005

Scottish Natural Heritage

Countryside access design guide, 2002

Centre for Accessible Environments/RIBA

Designing for accessibility, 2004
Good loo design guide, 2004

Rowntree Trust

Lifetime Homes – Habinteg Housing Association, c. 2003

Habinteg Housing Association

Wheelchair housing design guide, 2006

RNIB/JMU

Building Sight, 1995
Sign Design Guide, 2000

Appendix A

There are no strict technical criteria against which the DDA is or will be judged, however, reference to and use of guidance documents will support claims of reasonable provision.

The Centre for Accessible Environments (CAE)

Concerned with the practicalities of inclusive design in the built environment. Provide information, design guidance, training and consultancy services. http://www.cae.org.uk/

> * RIBA Enterprises and CAE have published a series of good practice guides. http://www.ribabookshops.com/site/featurelist.asp?i=1&HID544&H2ID=602

The Inclusive Environment Group (IEG), CABE

Key advisory body on built environment needs of disabled people, with a specific remit for access and inclusive design. Includes disabled people, regulators, built environment interests and observers from Government. Advises CABE's board of commissioners. http://www.cabe.org.uk/news/press/showPRelease.asp?id=739

The Disabled Persons Transport Advisory Committee

Advises the Government on access for disabled people to transport and advised on the built environment until development of CABE's IEG (see above). http://www.dptac.gov.uk/

> ** DPTAC have also developed a "commitment to inclusive design" model policy. http://www.dptac.gov.uk/inclusive/commitment/index.htm

The National Register of Access Consultants (NRAC)

Independent register of accredited Access Auditors and Access Consultants. http://www.nrac.org.uk/

The Research Group for Inclusive Environments (RGIE)

A focal point for disseminating information, developing collaborative projects and attracting further research related to accessibility within environments. http://www.rdg.ac.uk/ie/

The Disability Rights Commission (DRC)

An independent body established in April 2000 by Act of Parliament to stop discrimination and promote equality of opportunity for disabled people. http://www.drc-gb.org/

The European Institute for Design and Disability (EIDD)

A voluntary "umbrella" for national organisations whose members include architects, product, graphic and interior designers and professionals concerned with rehabilitation. EIDD is a founding member of the European Disability Forum (EDF).
http://www.design-for-all.org/

Employer's Forum on Disability

The employers' organisation focused on the issue of disability in the workplace.
http://www.employers-forum.co.uk/www/index.htm

Appendix B

With thanks to David Bonnett Associates and DPTAC

RIBA Work Stage	Process and Inputs	Practice Outputs	Controls
A/B Appraisal/design brief	Scope of services Briefing Access audit	Access statement	Access strategy
C/D Concept/design development	Access recommendations Audit plans Any funding submissions	Access statement (design/funding/ planning)	Planning Application
E/F Technical design/ production information	Design progress Record decisions and amendments	Access statement (design/funding/ planning)	Building Control Application
G/H Tender and contract		Record decisions	
J/K Mobilisation and construction	Site meetings	Assess and record changes Test installations	Building Control Testing at handover
L Post practical completion	Audit completed building Contribute to handover and operational information	Access statements for O&M manual	Access handbook (part of H&S file)
Review Post occupation	Monitoring and user feedback	Access review Access awareness and training as appropriate	DDA monitoring